CONTENTS

ENGLISH HERITAGE

INTRODUCTION

The images in this book show children and adults taking a break from their working lives and give us fascinating glimpses of people enjoying themselves from the early days of photography in the 1860s up to the 1960s.

It is common today for people to think about their work/life balance; time for leisure is seen as essential for individual happiness and wellbeing. The expression 'all work and no play makes Jack a dull boy' is not a modern one but fixed holidays and regular leave from work was rare in the 1860s. It was not until 1871 that bank holidays were introduced and only in the twentieth century have weekends off and paid annual leave spread to include the majority of workers.

The introduction of bank holidays allowed working class people to take advantage of the emerging rail network, taking day trips to local beauty spots. Enterprising Victorian photographers recorded bank holiday scenes such as the picnic at Uffington Castle in 1900 (page 19). Seaside resorts also benefited from increased rail travel and bank holidays and were expanded to include new promenades, piers and attractions.

Before the 1870s working people generally had only one day off a week, usually a Sunday. In those days everyone was expected to go to church on a Sunday morning. In the afternoon gentle leisure activities such as going for a walk or visiting friends and relatives were the norm. By this time people were moving in large numbers from

rural areas to towns and cities where public parks were being laid out to encourage healthy recreation. The only other days when people came together to enjoy themselves were local feast days or traditional events such as St Giles' Fair (pages 65, 67 and 68). These festivals often dated back many centuries and were recorded, and even sometimes revived, during Victorian times when photographers such as Henry Taunt saw them as opportunities to photograph local people and, no doubt, sell them copies of the photographs they took. He and others such as Alfred Newton took a close interest in the traditions of 'Merrie England', taking photographs of Morris Men (page 87) and country dancing (page 69). On these days whole communities took the opportunity to enjoy themselves, eat and drink, meet with friends and find sweethearts.

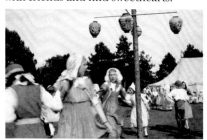

These early photographers were very quick to seize the opportunity to make a profit from the new phenomena of holidays and day trips. Henry Taunt travelled along the Thames in a specially adapted barge taking photographs at events like Henley

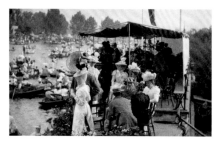

Regatta (page 14) which he used to illustrate tourist guides that he then published. Other photographers branched out into the picture postcard business.

Changes in transport continued to affect how people spent their leisure time. The invention of the bicycle allowed men and women new opportunities for sport and travel, from the Victorian cycle club in Hyde Park (page 81) and the Misses Bromley pictured with their bikes in 1904 (page 80) to the man and his tandem in the 1930s (page 8).

Another major change came in the 1920s and '30s with the spread of the motor car. Although not many people owned a car, coaches and charabancs conveyed large numbers to the coast where many new recreational buildings were appearing. Open air pools and lidos like those at Skegness (page 13) and Roehampton (page 94) were all the rage. New trunk roads with roadside pubs were built and caravanning became popular. The 1930s also saw the start of air travel, recorded in John Gay's photograph of Heathrow (page 10).

Most leisure was, however, still centred nearer home. Visiting the cinema was the most popular pastime in the '30s with spectacular buildings such as the News Cinema (page 38) and Odeon (page 41) dominating High Streets all over the country.

It was not until recently that most people started regarding Sunday as a day for enjoying a large range of leisure activities. People who grew up in the 1950s will remember that it was not acceptable for children to play out in the street on a Sunday. Nor did adults and families go to the cinema, visit shopping centres or spend time in a leisure centre on a Sunday as they might today. When families did go out they went dressed in their best as you can see in the picture of the boating lake at Great Yarmouth taken in 1948 by Hallam Ashley (page 18). There was no concept of having special casual clothes for leisure in the 1940s or '50s.

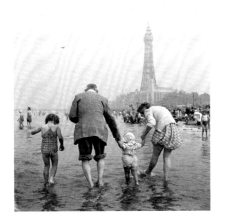

The seaside was still a big draw, often reached by steam trains caught at local stations. John Gay's 1949 view of a family in the sea at Blackpool showing stitched bathing costumes, bathing caps and girls with skirts tucked into their knickers (page 28) will bring back memories for many people. A cheaper alternative for East Enders is well illustrated in the photograph of Tower Beach (page 7). It appears that London's new idea for a beach on the South Bank in 2007 may not be so new after all.

Sport is a major leisure activity today, both taking part and watching, and there are historic images of tennis, cricket, fishing, golf, hockey, and rowing in this collection that remind us of their long histories. The Edwardian ladies playing hockey in long skirts at Somerville College (page 107) make us wonder how they coped. The regatta at Beer in 1950 (page 95) seems to be from another age and even the Wembley Twin Towers (page 112) are now just a memory.

This book explores many themes and provides an insight into the changes in leisure over the past hundred years. Of course, some things have not changed very much. People still visit beauty spots such as Dovedale (page 16) and go out into the countryside for picnics (page 53) or to enjoy rambling, even if the clothes, cars and rucksacks look different. The old men watching a football match in the park (page 98), the boys fishing at Abingdon (page 79) and the skaters on the Serpentine

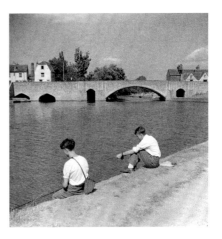

(inside front cover) and in Richmond Park (page 84) are timeless evocations of a world at leisure.

Mary Mills
Education Officer
English Heritage NMR

HOLIDAYS &
DAYS AWAY

"WE used to go to the seaside once a year on buses, or by train. We used to take a penny a week to school to save up for the trip. We couldn't afford to go away for a week. We just used to play on the sands because we had no money for anything else."

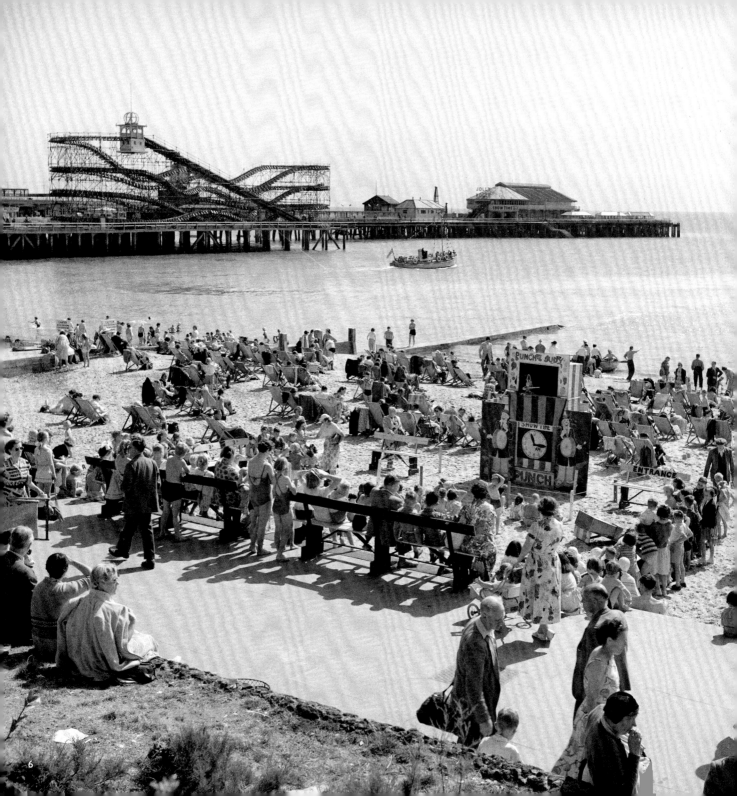

The beach and pier at
Clacton-on-Sea, Essex.
Hallam Ashley
1953

Tower Beach, Greater London.
S W Rawlings
1945-1965

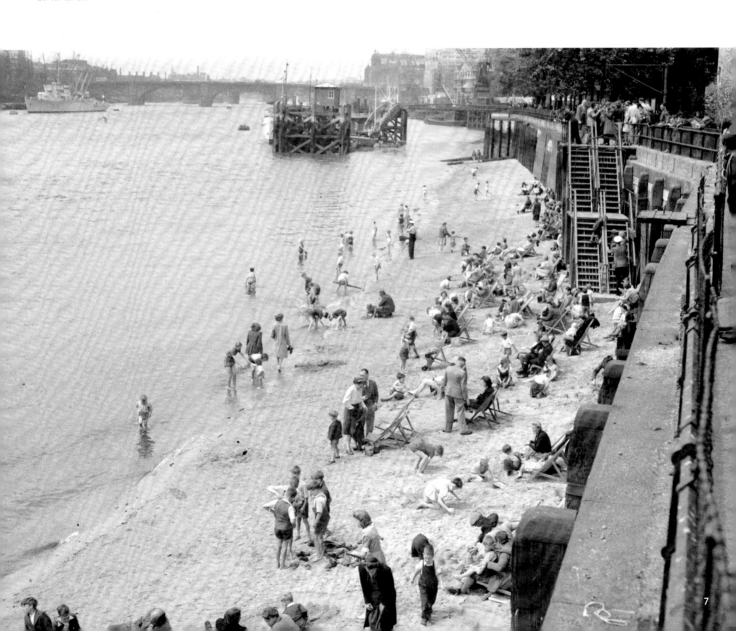

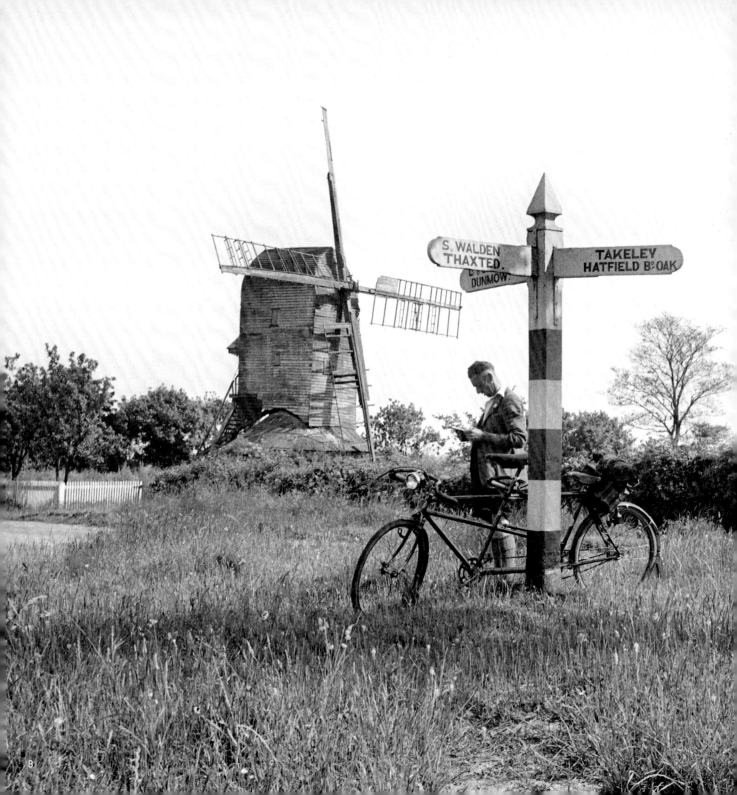

Cycling at Broxted, Essex.
HES Simmons
1930s

9

Holiday goers at Heathrow
Airport, London.
John Gay
1955-1965

Day trippers visiting the market
at Ross-on-Wye, Herefordshire.
Eric de Maré
1945-1960

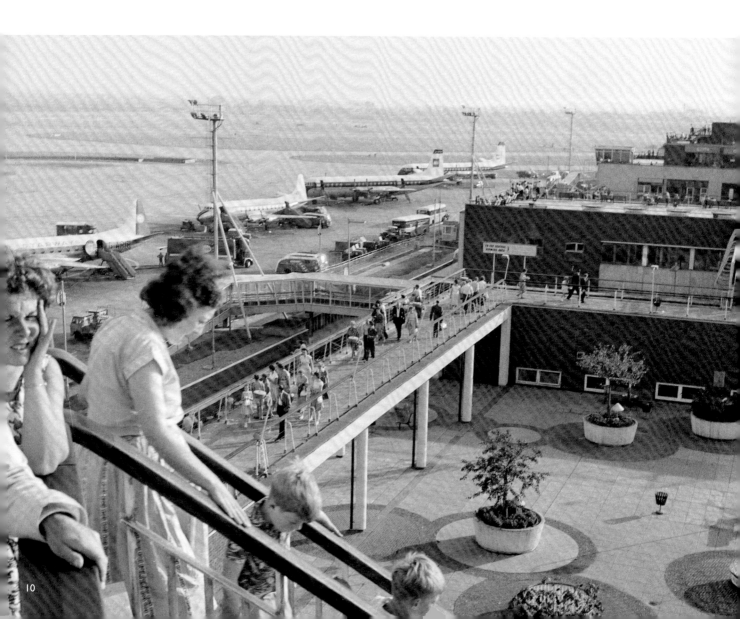

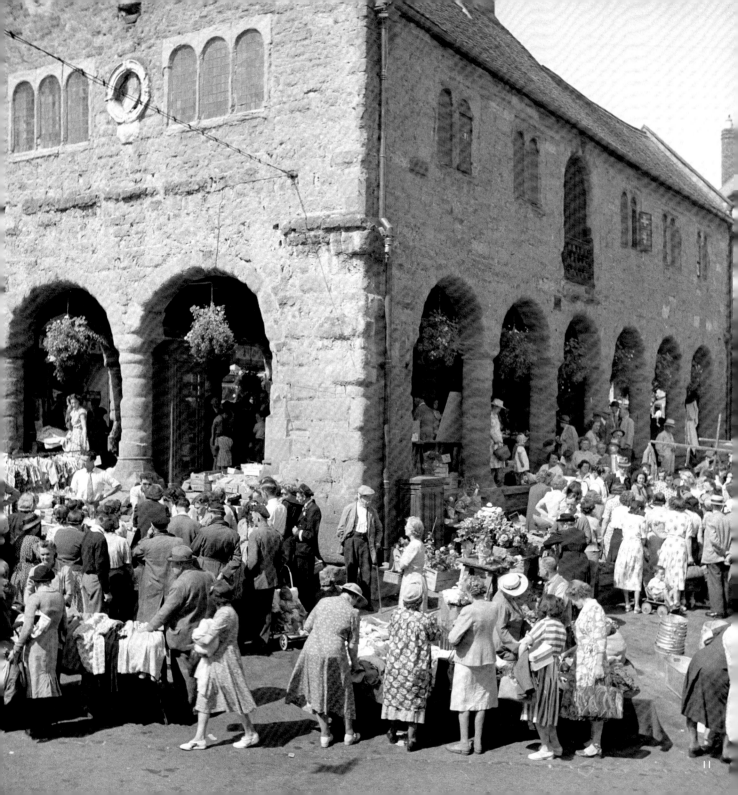

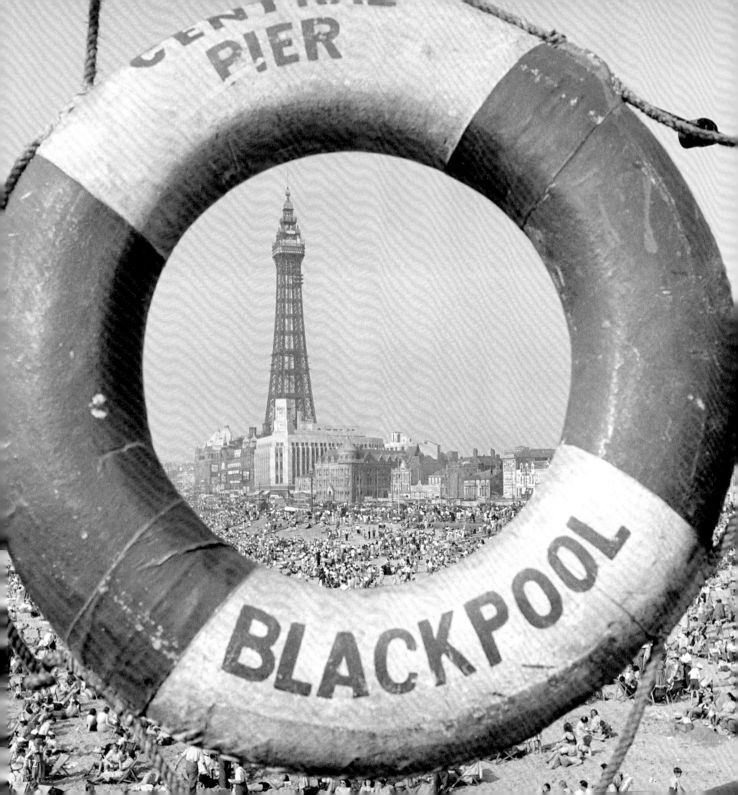

Blackpool Tower and beach,
Lancashire.
John Gay
1949

Skegness open air swimming
pool, Lincolnshire.
Hallam Ashley
1960

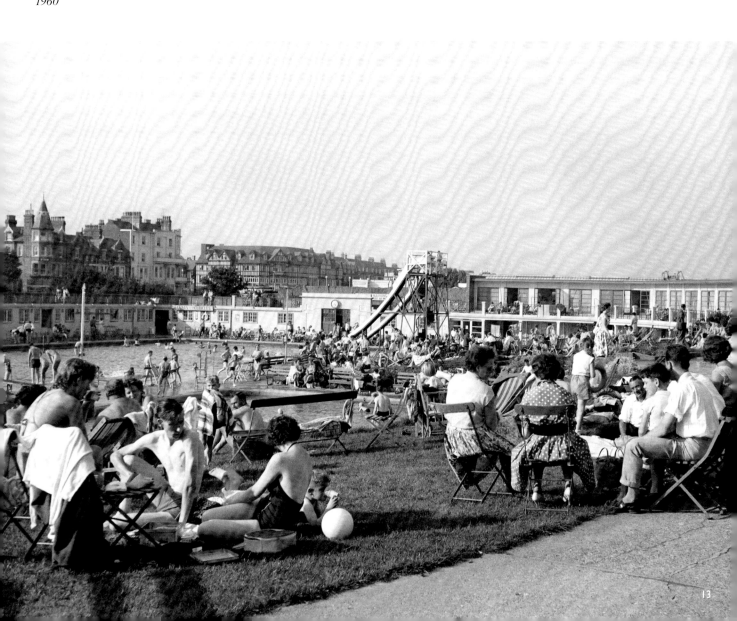

Taking tea at the Henley
Regatta, Oxfordshire.
Henry Taunt
1897

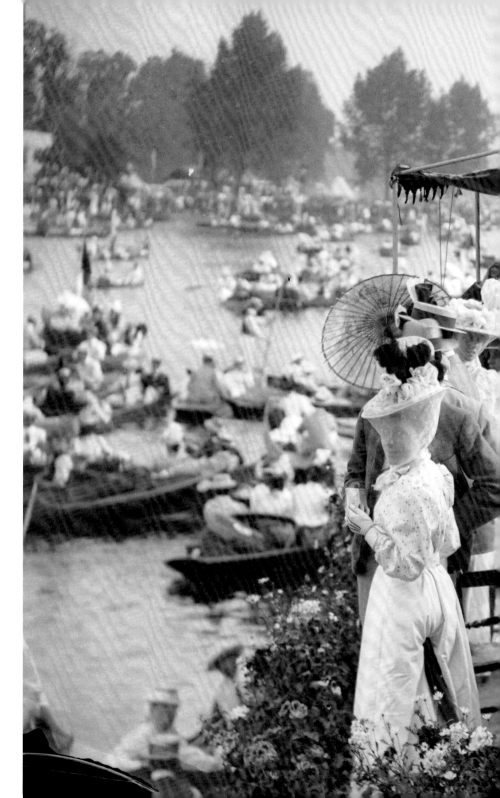

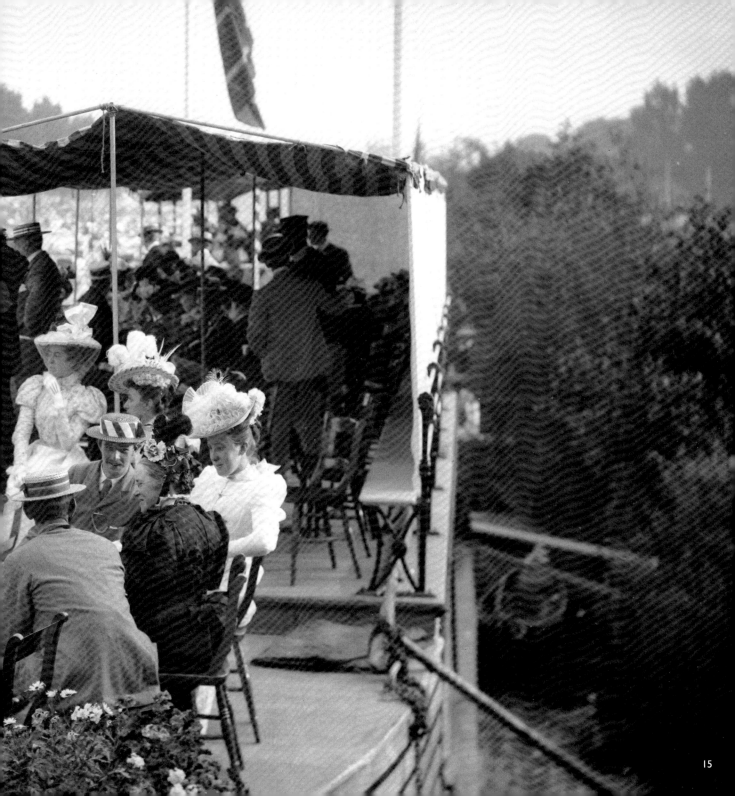

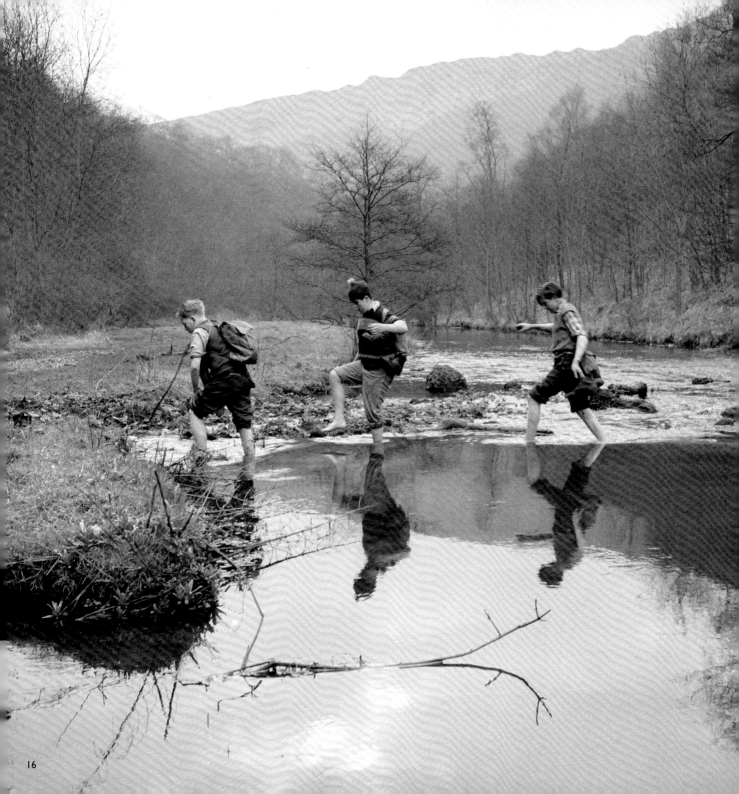

Rambling in Dovedale,
Lake District, Cumbria.
John Gay

Getting ashore at
Ladram Bay, Devon.
John Gay

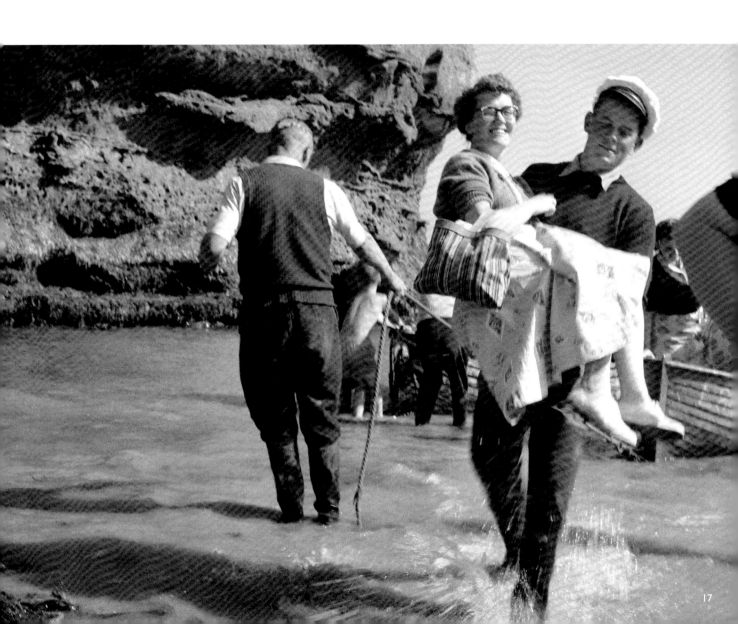

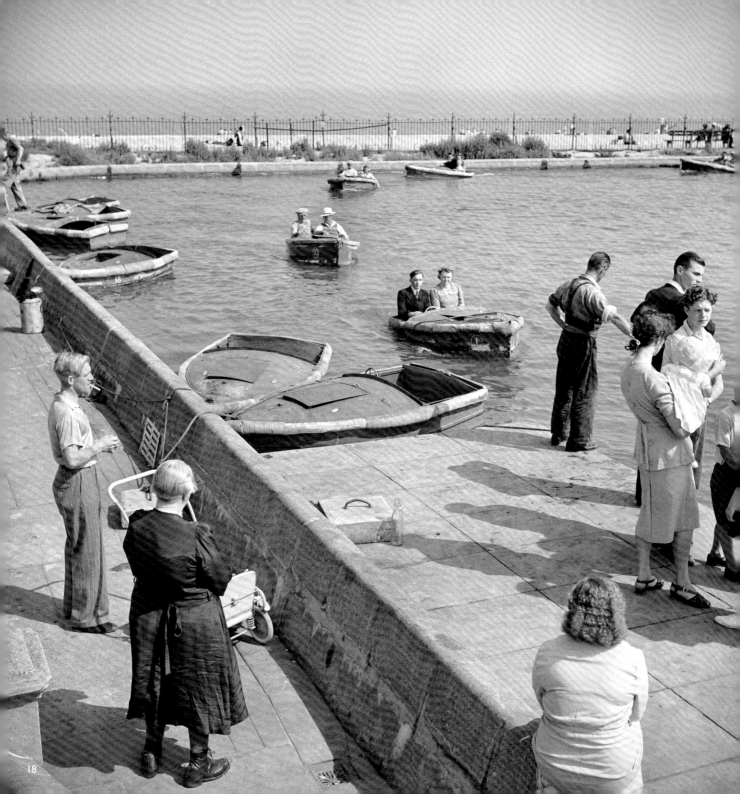

Boating lake, Great Yarmouth,
Norfolk.
Hallam Ashley
1948

Bank Holiday visitors to
Uffington Castle, Oxfordshire.
Henry Taunt
1900

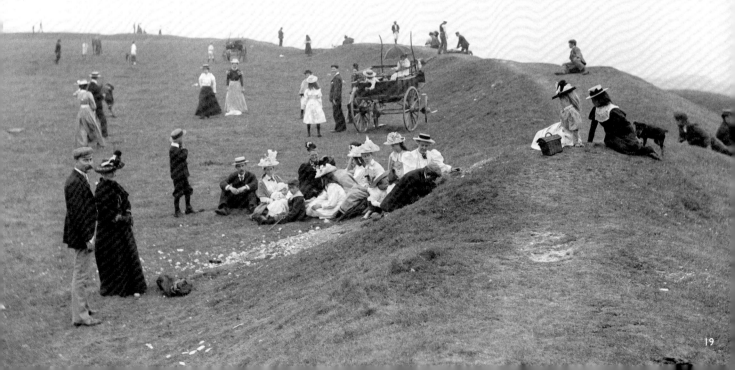

Inside a cruiser on the
Norfolk Broads, Norfolk.
Hallam Ashley
1957

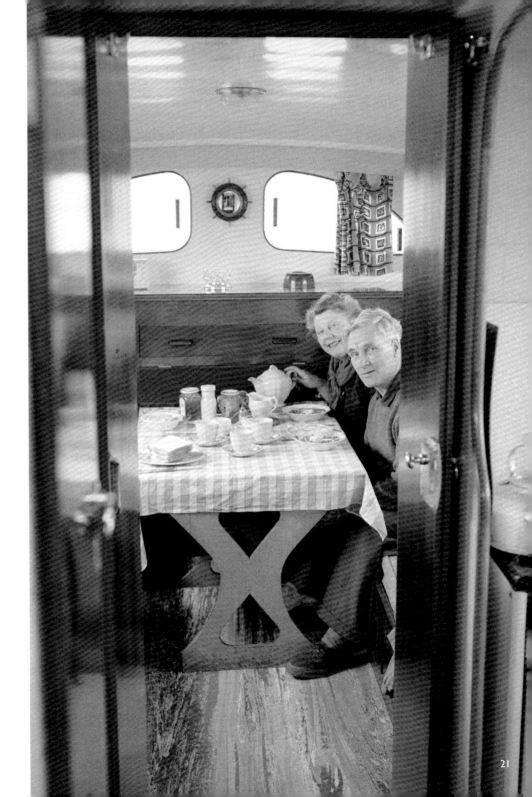

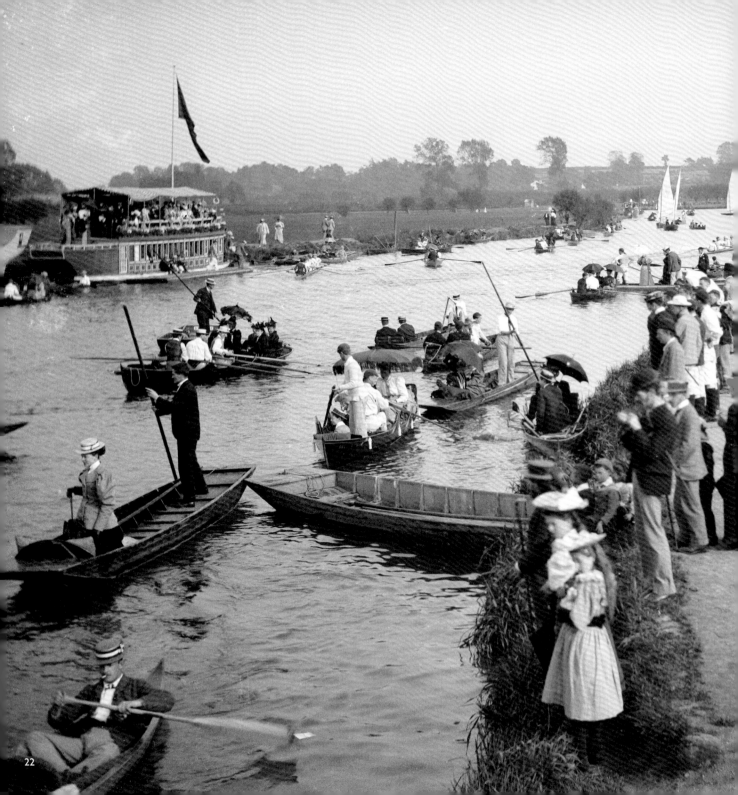

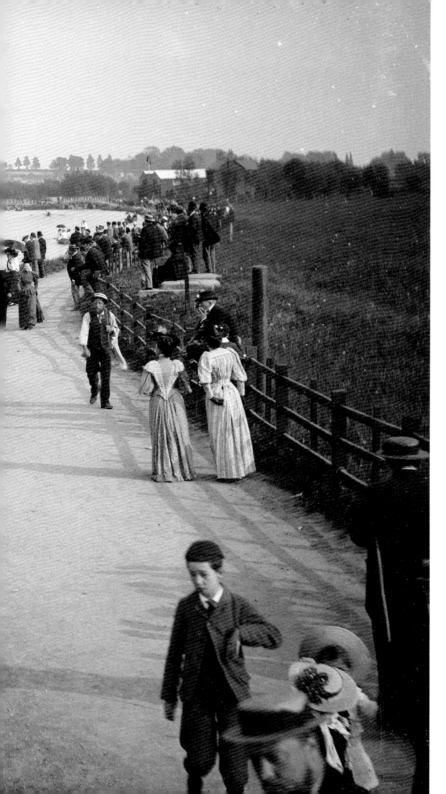

Punting on the River Thames
near Oxford, Oxfordshire.
Henry Taunt
1880-1920

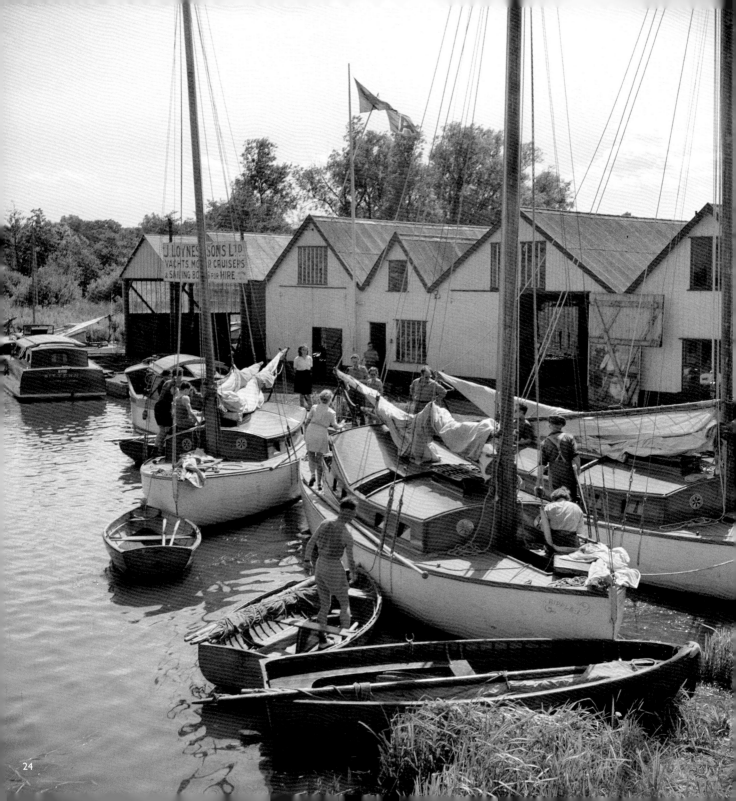

Hiring a boat at J Loyness and Sons,
Wroxham, Norfolk.
Hallam Ashley
1947

Sailing on the River Ant, Turf Fen,
Norfolk.
Hallam Ashley
1955

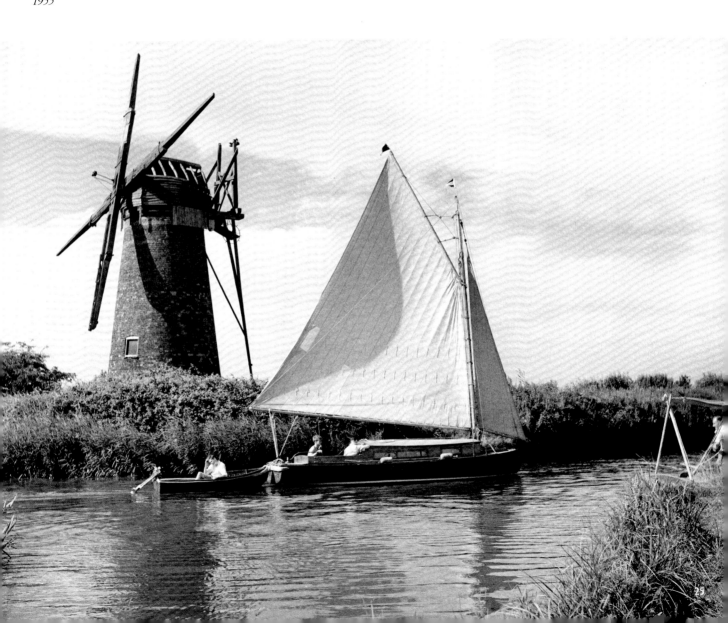

Caravanning near Bridgnorth,
Shropshire.
John Gay

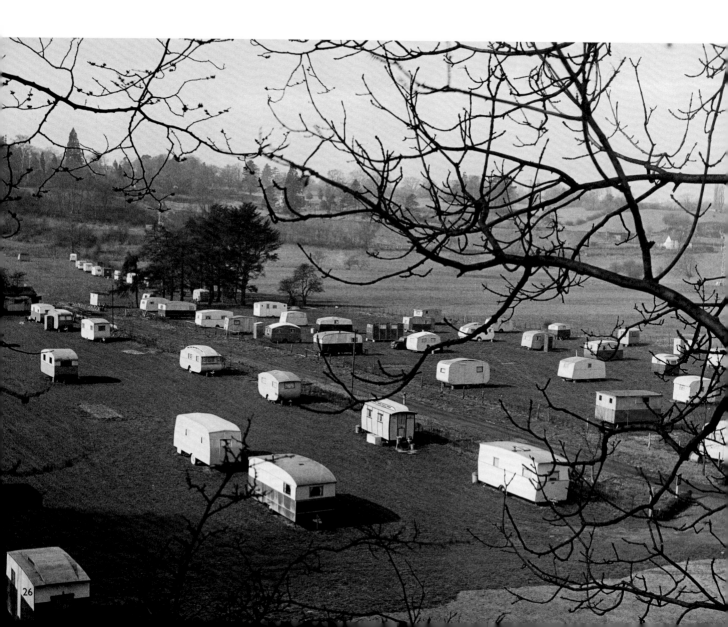

Punting on the River Cam at
Grantchester, Cambridgeshire.
John Gay

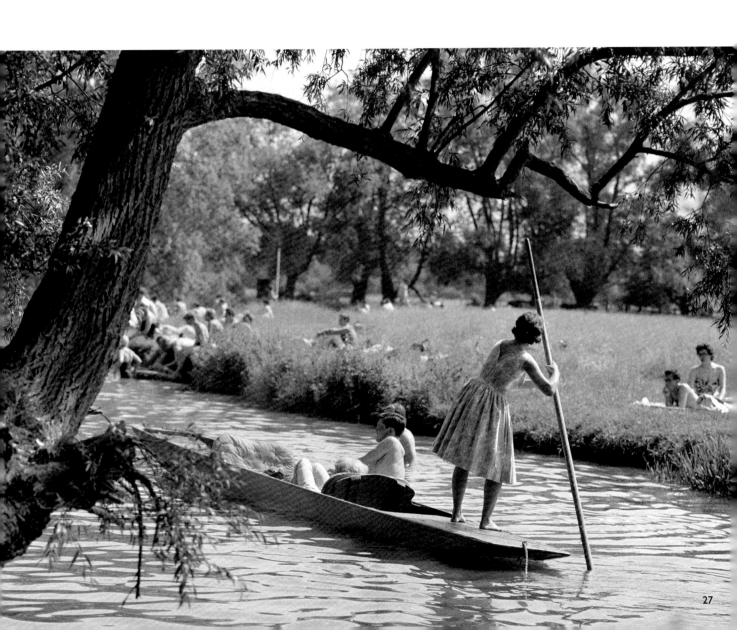

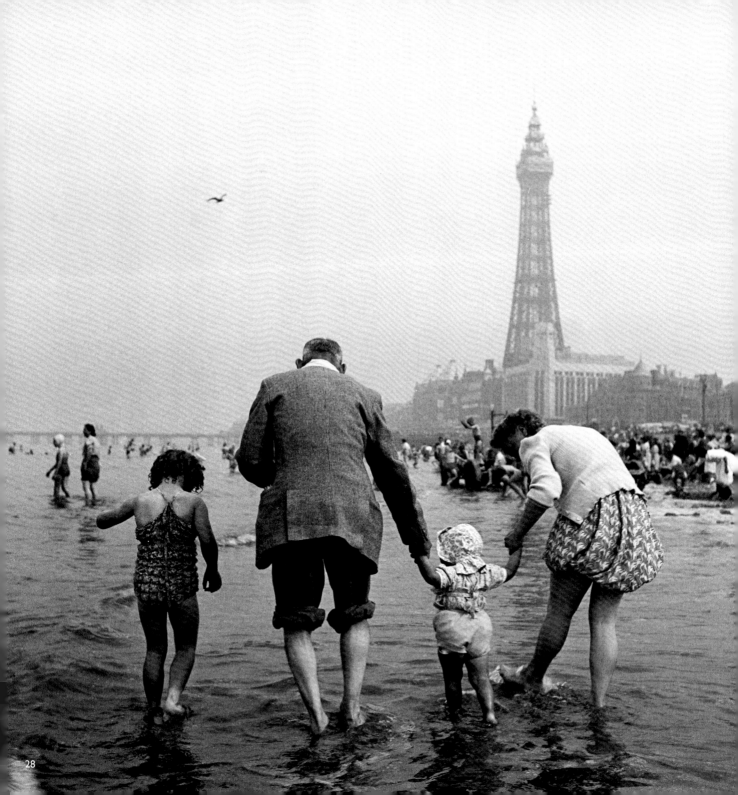

Paddling on Blackpool beach,
Lancashire.
John Gay
1949

The Winter Gardens and Great
Wheel, Blackpool, Lancashire.
W and Co.
1890-1910

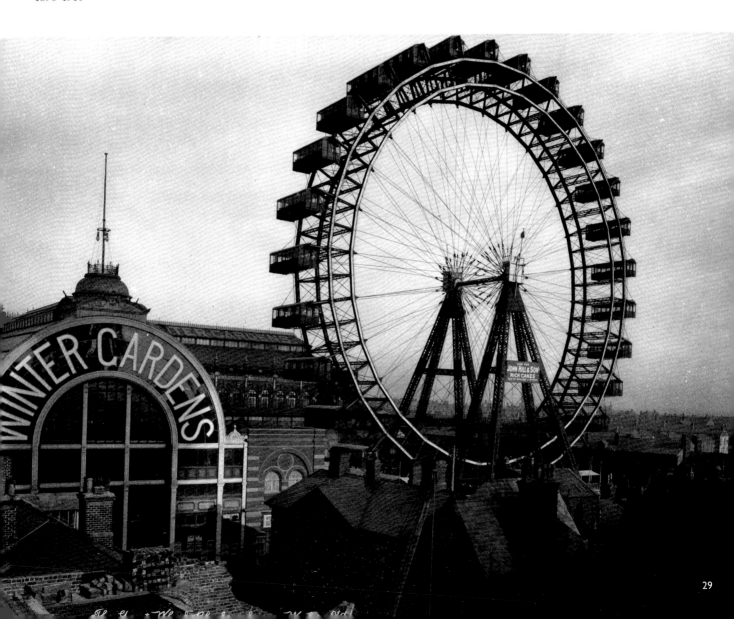

ENTERTAINMENT

"*A GROUP of us would go to listen to the band. Some of us wore bowler hats – you never went out of the house without a hat in those days, or a cap during the week. We carried silver topped canes. All dressed up we thought we were 'Lord Muck'.*"

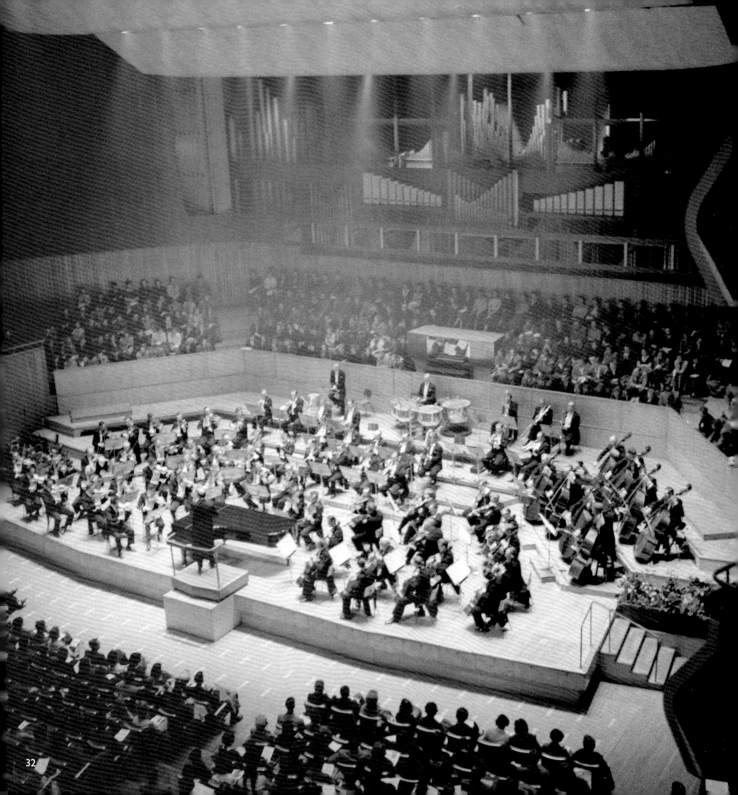

A concert at the Royal Festival Hall,
South Bank, London.
Eric de Maré
1954-1962

A Ragtime band playing at Maison
Lyons, Oxford Street, London.
Bedford Lemere
1916

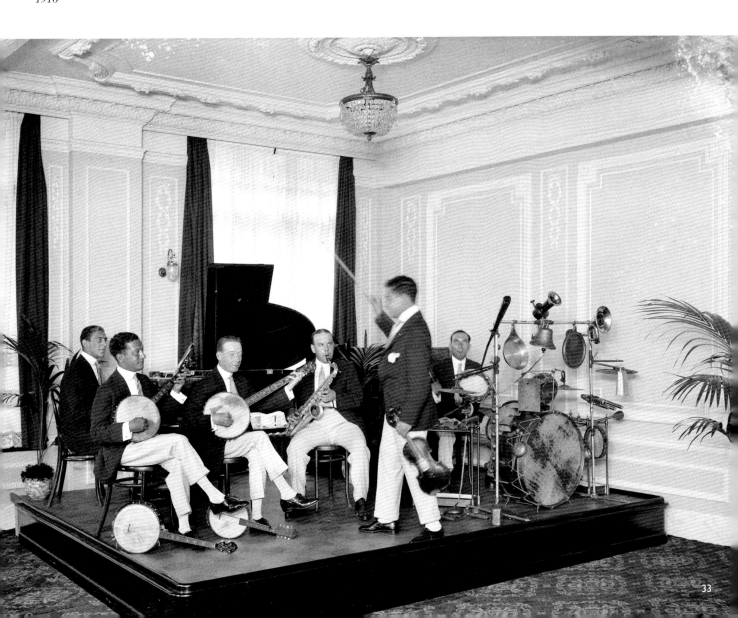

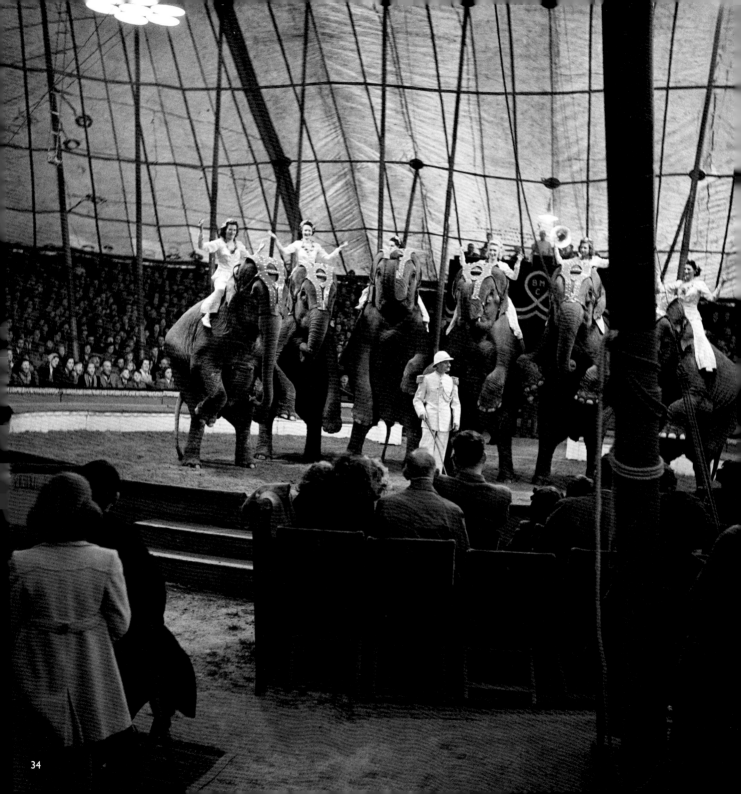

Elephants at Bertram Mills Circus,
Norwich, Norfolk.
Hallam Ashley
1948

Dodgem cars at Battersea funfair,
London.
Laurence Goldman
1961

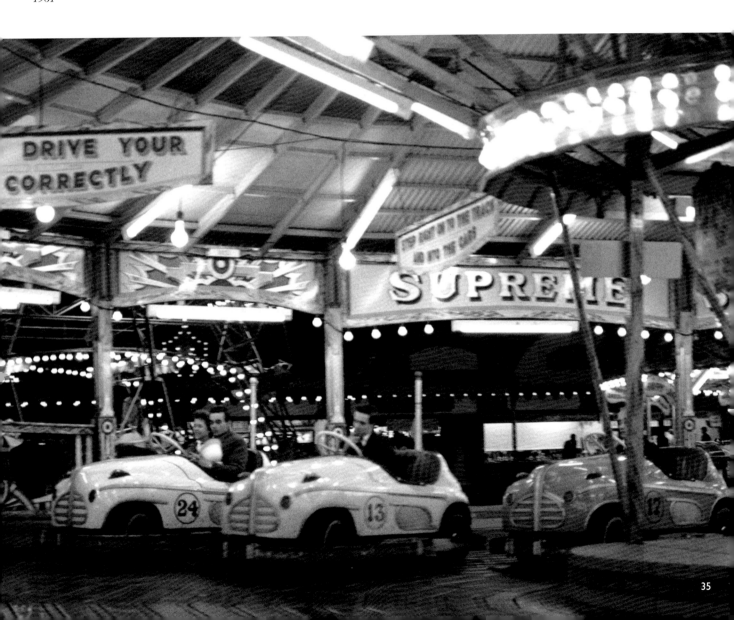

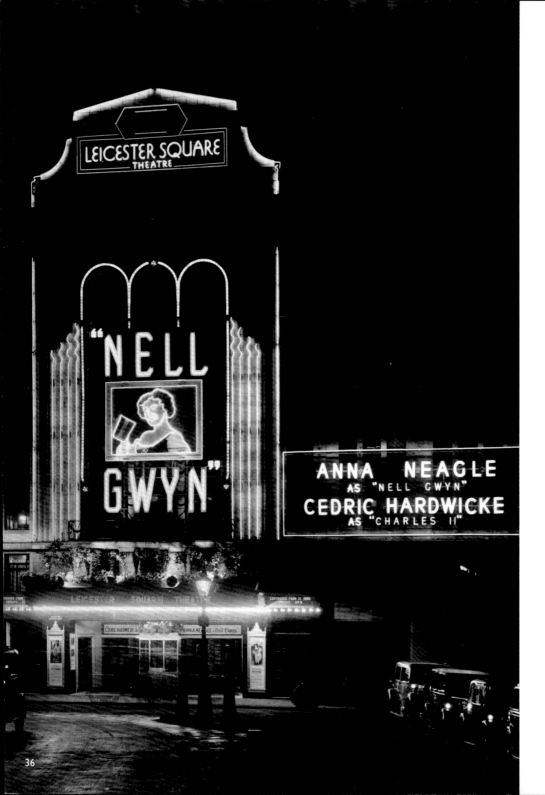

The neon lit Leicester
Square Theatre, London.
Larkin Bros
1930

The Big Dipper at Festival
Gardens, Battersea Park,
London.
John Gay
1946-1959

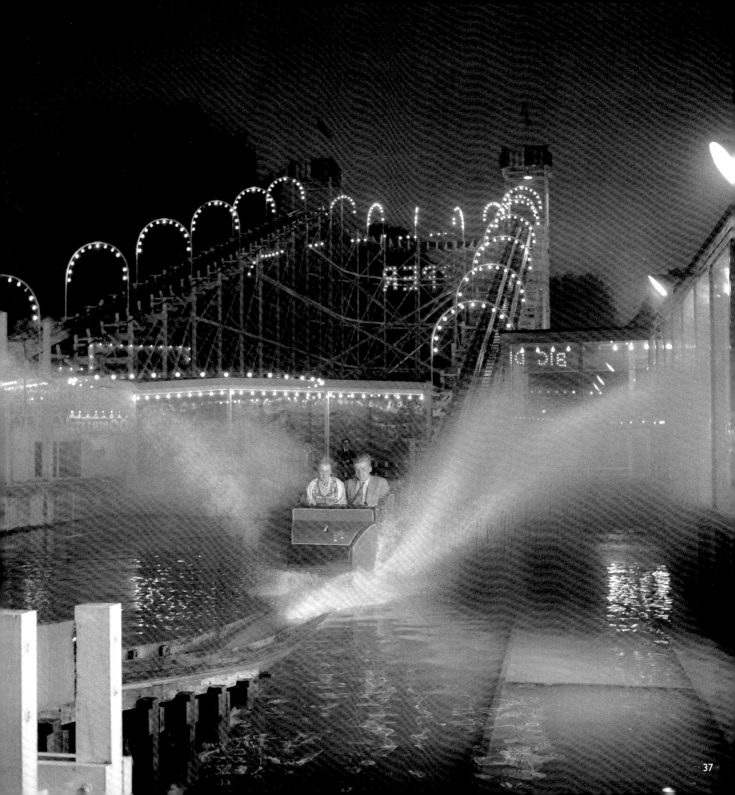

The deco style News Cinema
at Victoria Station, London.
Herbert Felton
1933

Playing cards at a Highgate
Society meeting, London.
John Gay
1946-1980

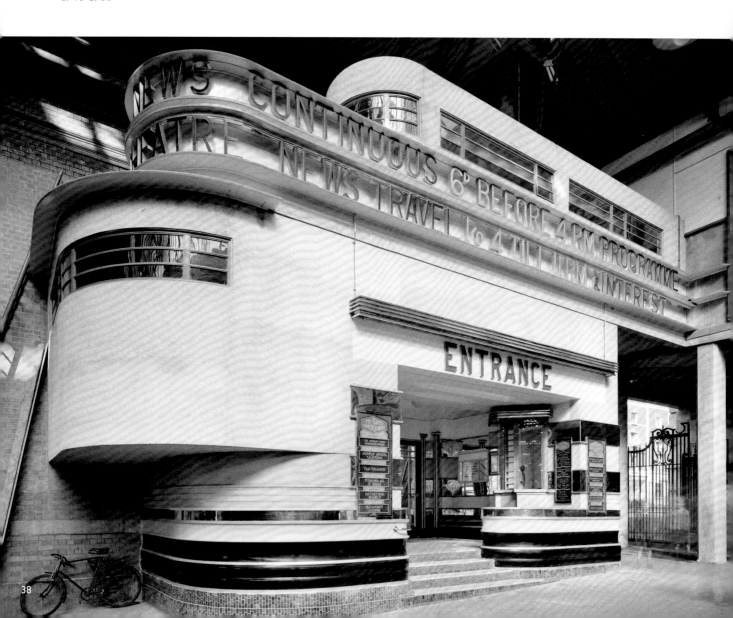

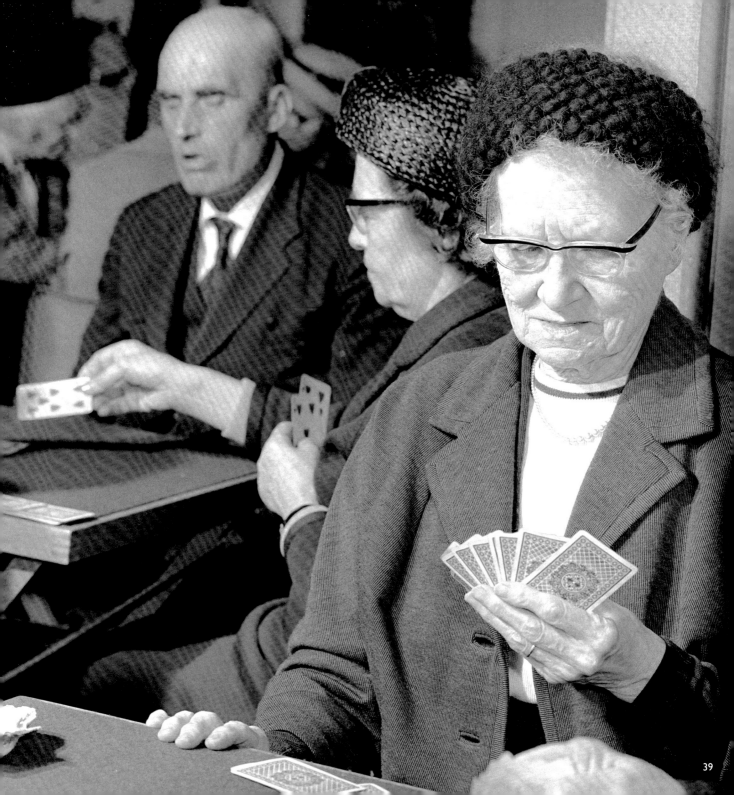

Children queue outside the
Palace Cinema Eltham, London.
John Maltby
1935

The Odeon Cinema,
Leicester Square, London.
John Maltby
1937

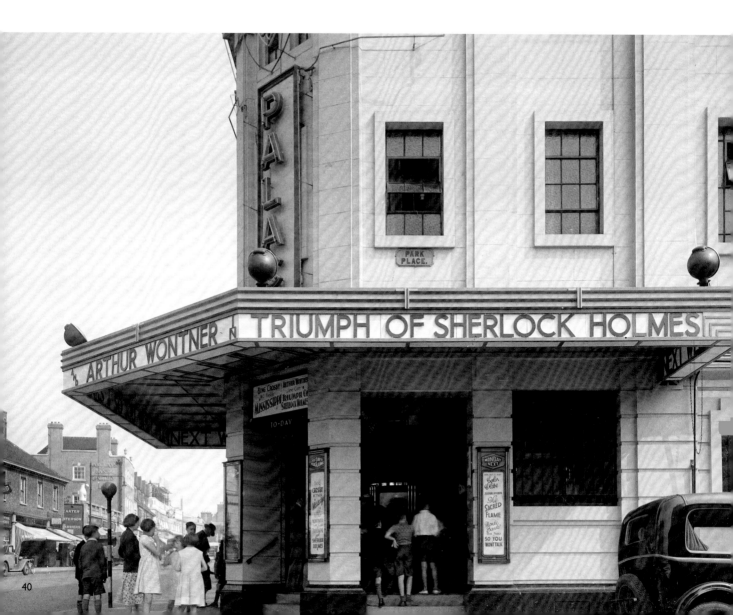

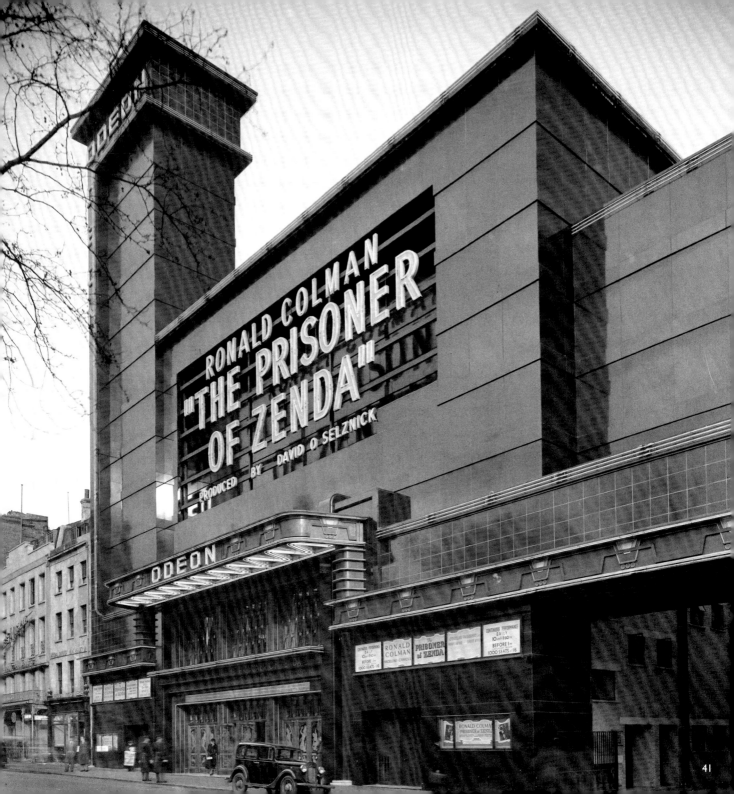

RONALD COLMAN
"THE PRISONER OF ZENDA"
PRODUCED BY DAVID O SELZNICK

ODEON

41

A musical interlude, Princes Risborough,
Buckinghamshire.
Alfred Newton and Son
1896-1920

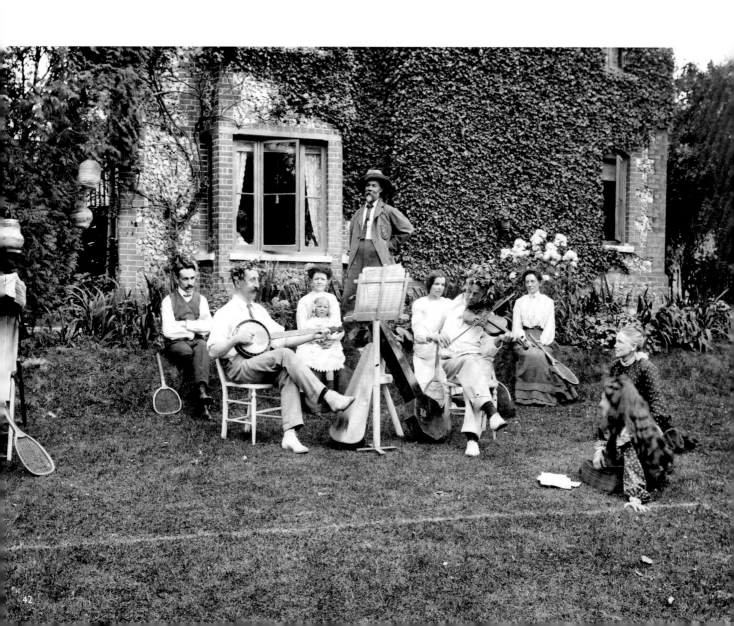

Race day at Epsom racecourse,
Surrey.
York and Son
1870-1900

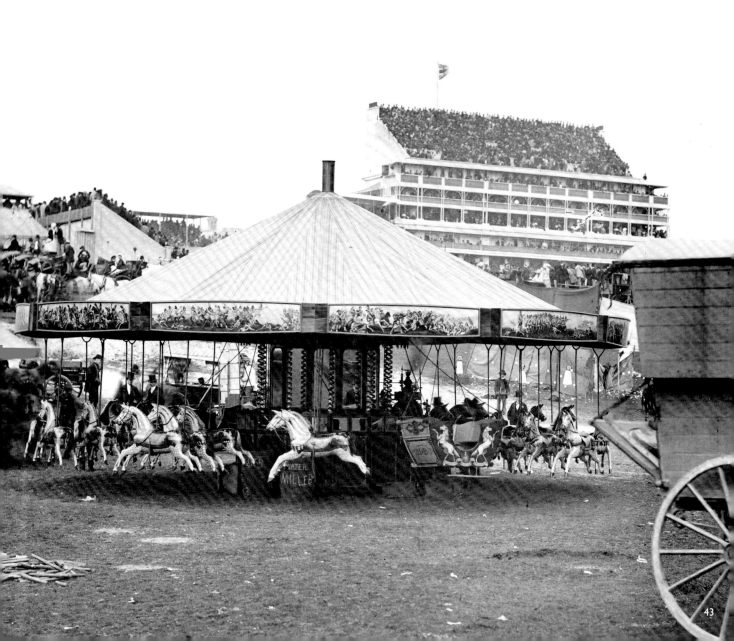

FOOD & DRINK

"WE would go down to the chip shop and get chips and sloppy peas for tuppence. In old money this was called a 'smile'. You had to take your own basin for the peas."

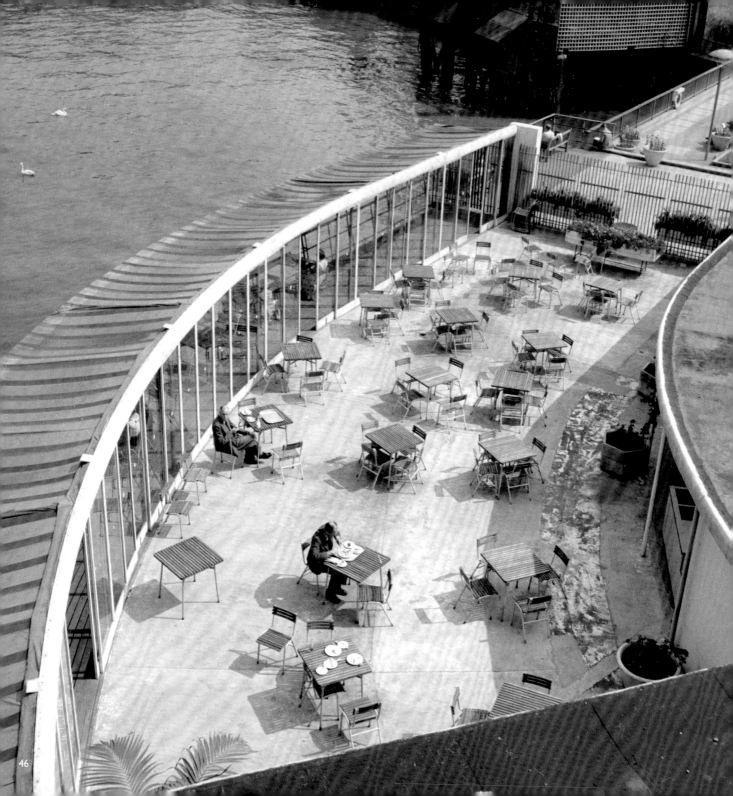

The Royal Festival Hall café terrace,
South Bank, London.
S W Rawlings
1951-1965

Drinking outside the George Inn,
Botley, Oxfordshire.
Henry Taunt
1892

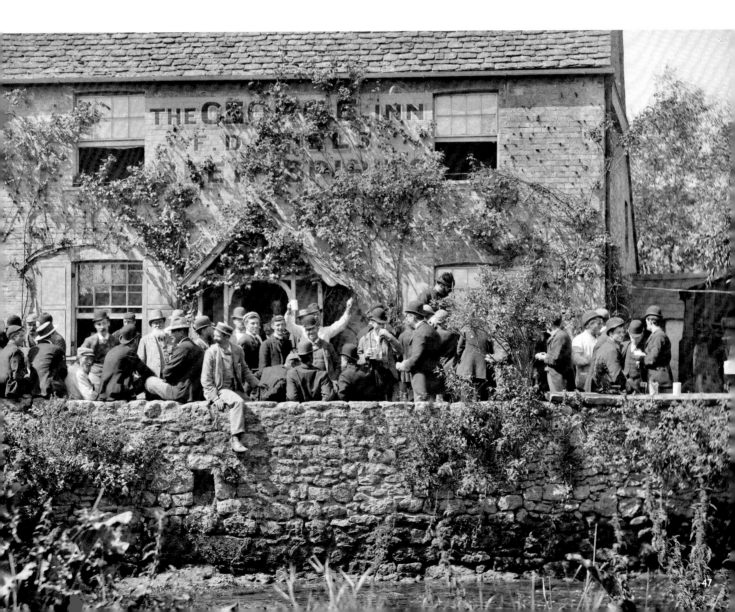

Centre Bar, The Gloucester Arms,
Penrith, Cumbria.
E W Tattersall
1950

A pub on the Edgware Road,
London.
John Gay
Pre 1964

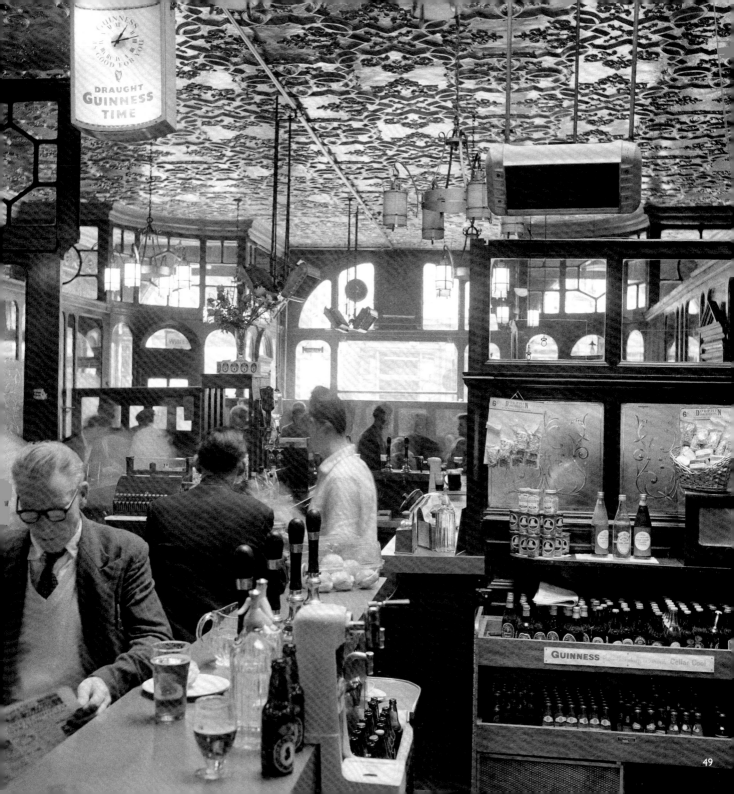

DRAUGHT GUINNESS TIME

GUINNESS

Cellar Cool

49

The café at the Odeon Cinema,
Scarborough, North Yorkshire.
John Maltby
1936

The Luncheonette and Soda Fountain
Restaurant, Lewis's Department Store,
Leicester, Leicestershire.
Herbert Felton
1936

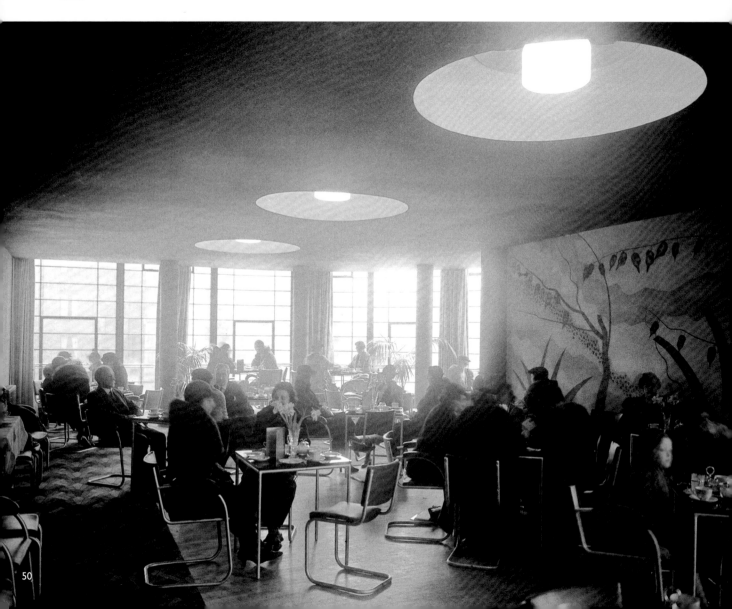

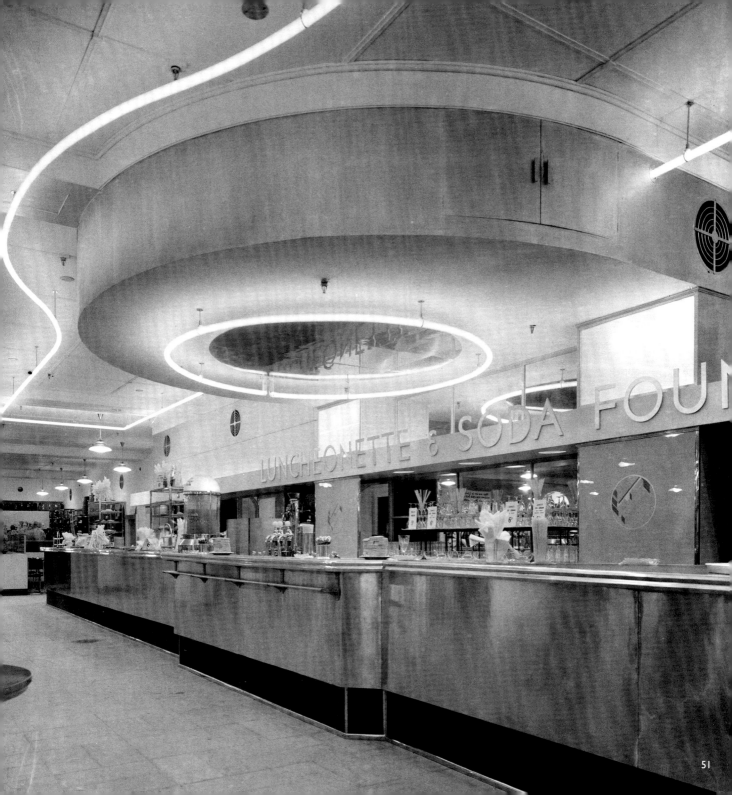

LUNCHEONETTE & SODA FOUN

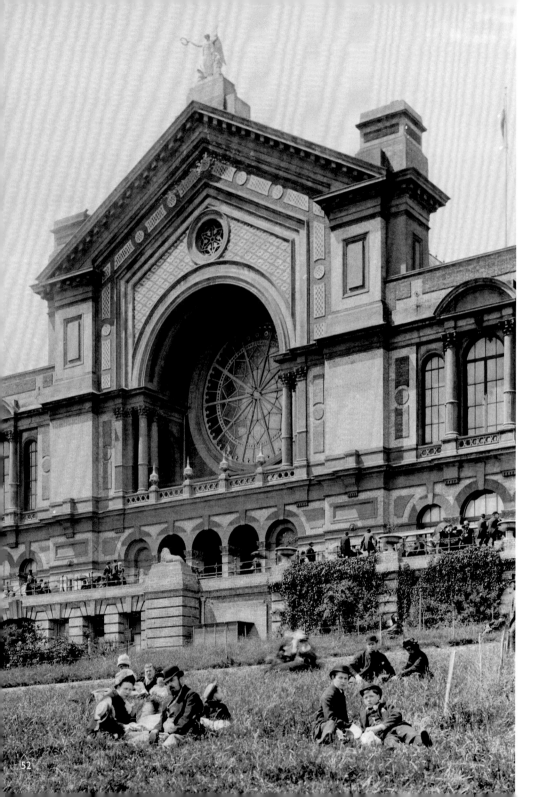

Picnicking at Alexandra
Palace, London.
York and Son
1873-1900

Picnicking in Monsal Dale,
Derbyshire.
Hallam Ashley
1955

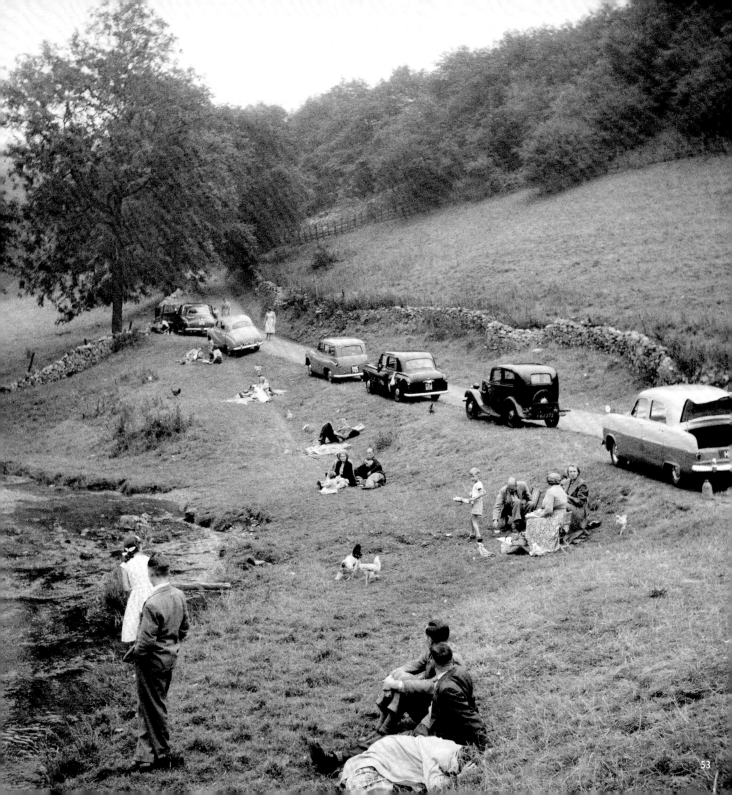

The Vienna Café on New
Oxford Street, London.
Bedford Lemere
1897

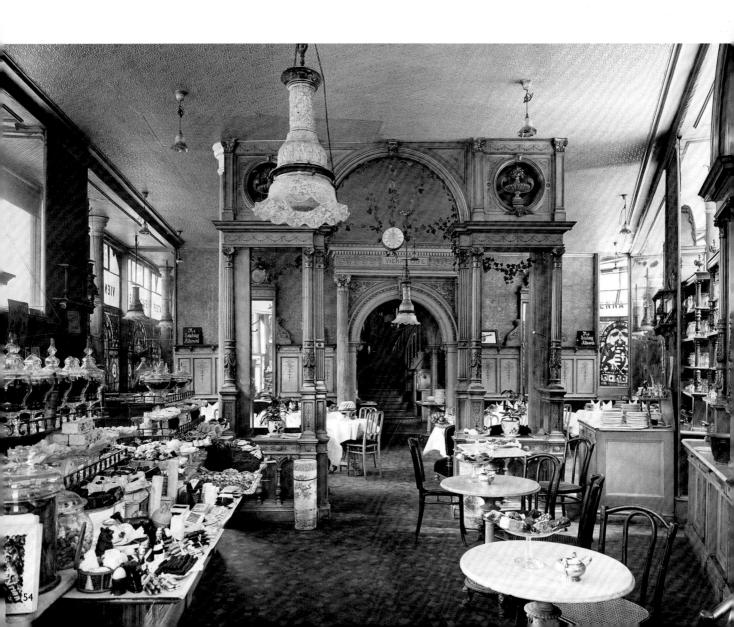

54

Customers at the Honey Dew Restaurant,
Coventry Street, Westminster, London.
Herbert Felton
1930s

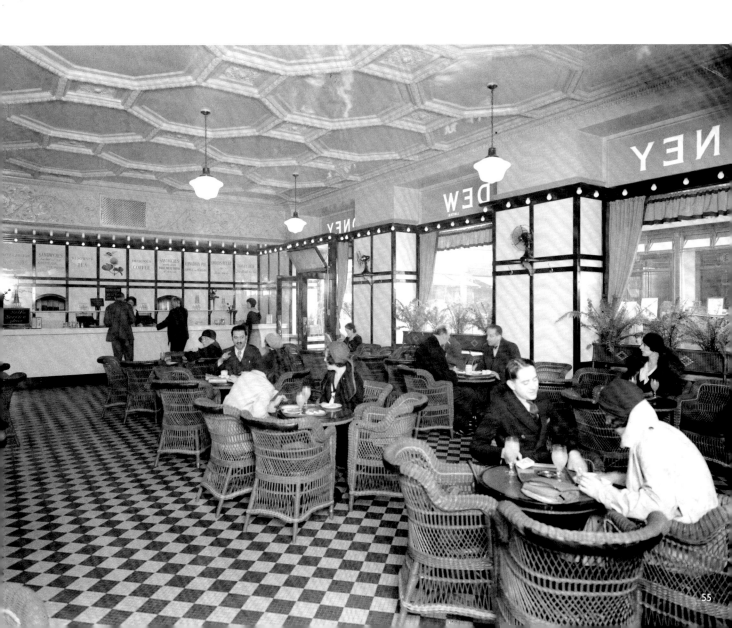

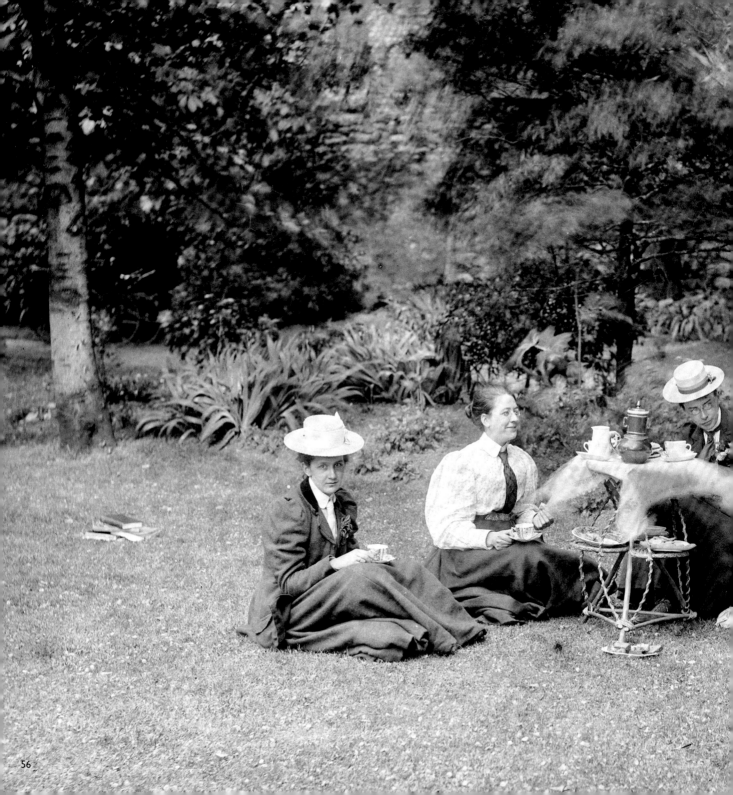

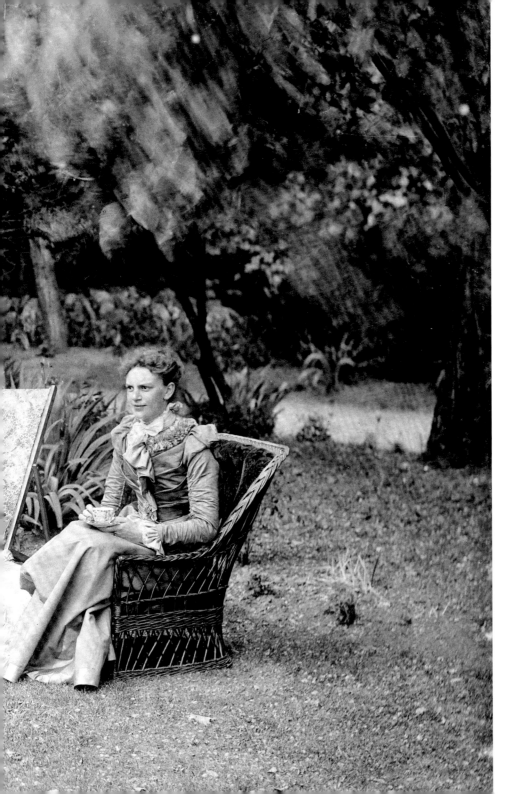

Students taking tea
in the grounds of
Somerville College,
Oxford, Oxfordshire.
Henry Taunt
1895

FETES & FAIRS

"*THE feast was a big event in the village. All the children would be excited as the big day drew near. I remember my brother and his pals would get down on the ground, put their ears to the ground, and listen for the sound of the wagons coming.*"

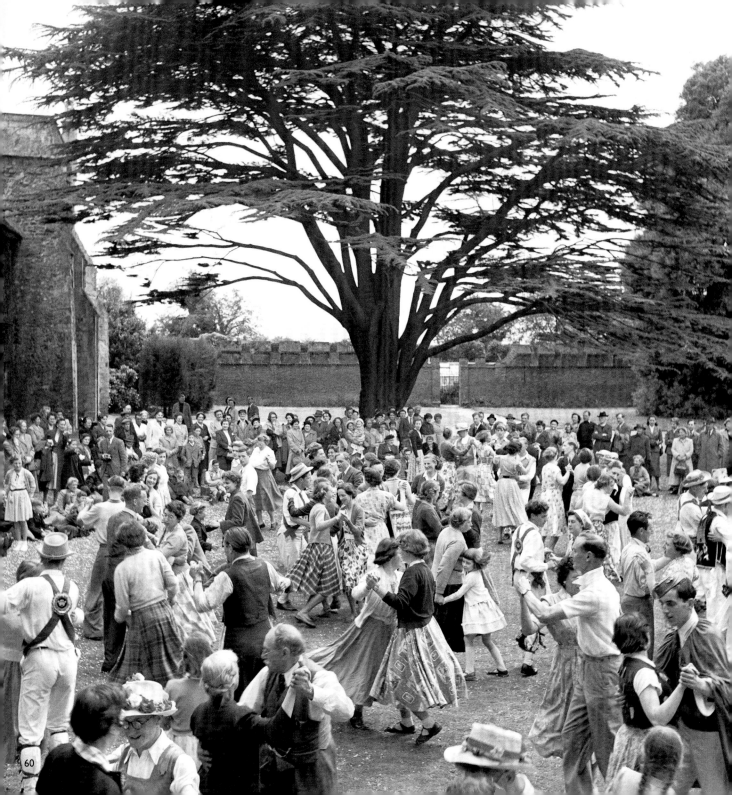

Dancing at Chichester, Sussex.
John Gay

Pearly king and queen crown the
donkey derby winner in Sussex.
John Gay

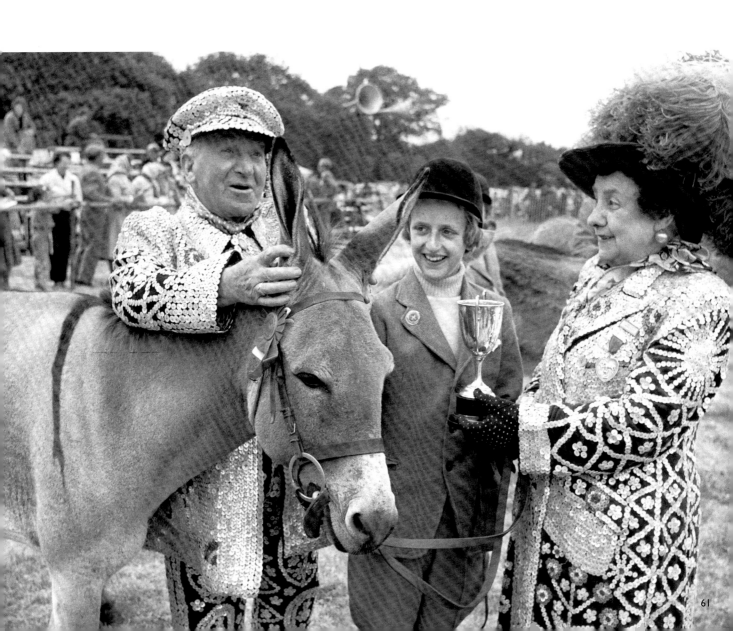

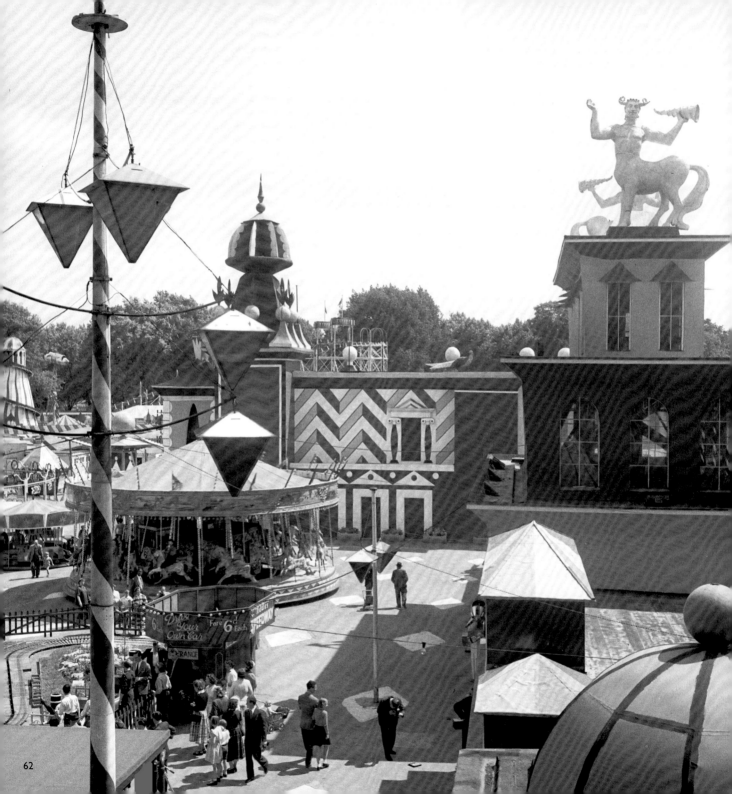

Fairground amusements in
Battersea Park Festival Gardens,
London.
Eric de Maré
1951

Stall at a garden fete at
Hellidon House, Northamptonshire.
Alfred Newton and Son
1896-1920

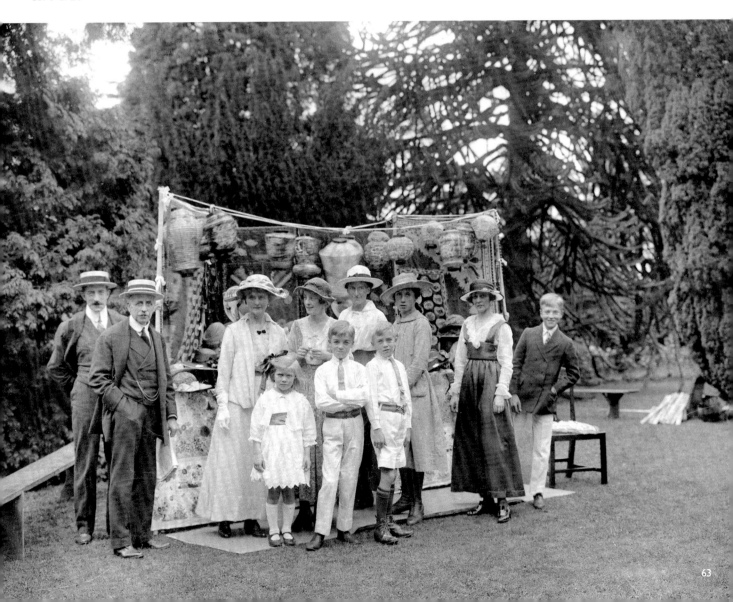

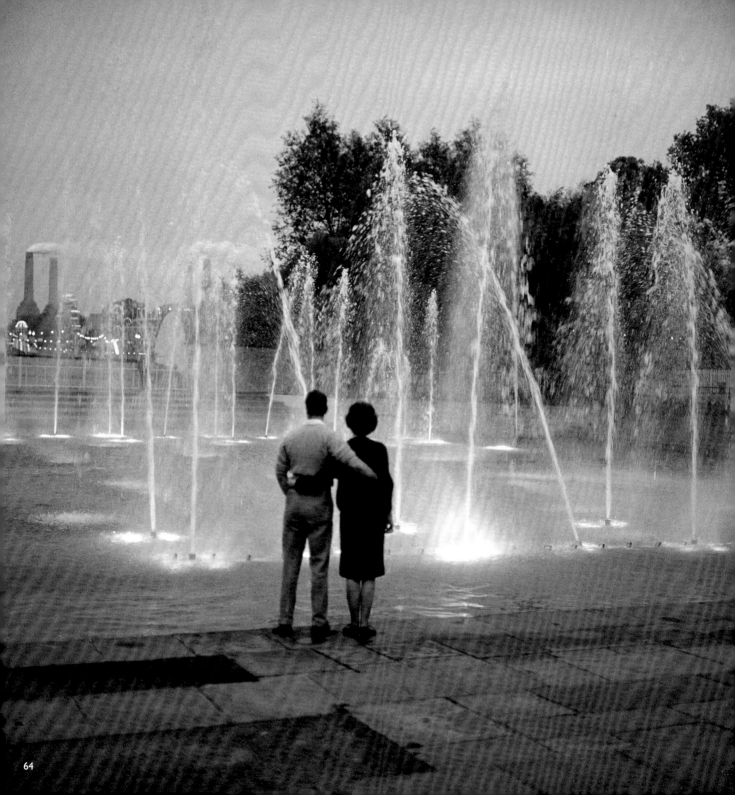

Admiring the fountains at
Battersea funfair, London.
Laurence Goldman
1961

A carousel at St Giles' Fair,
Oxford, Oxfordshire.
Henry Taunt
1895

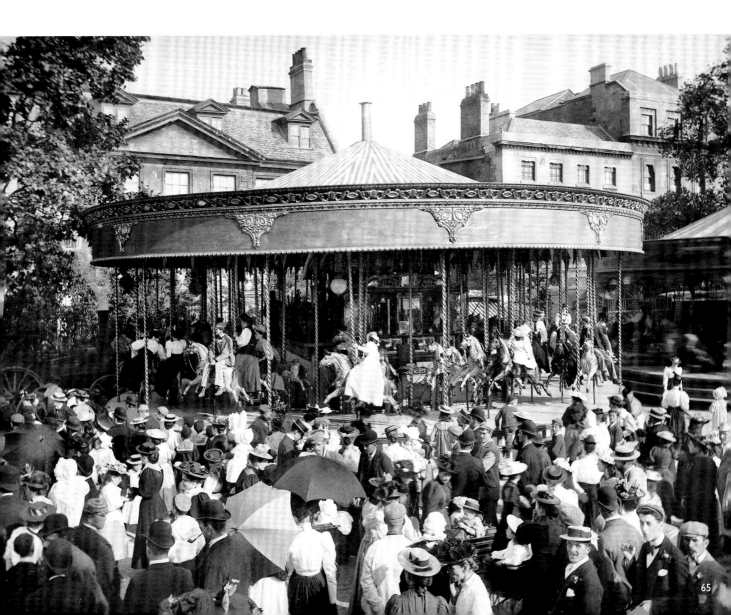

Having tea at 'Ye Olde Country Faire',
Grendon Hall, Buckinghamshire.
Alfred Newton and Son
1913

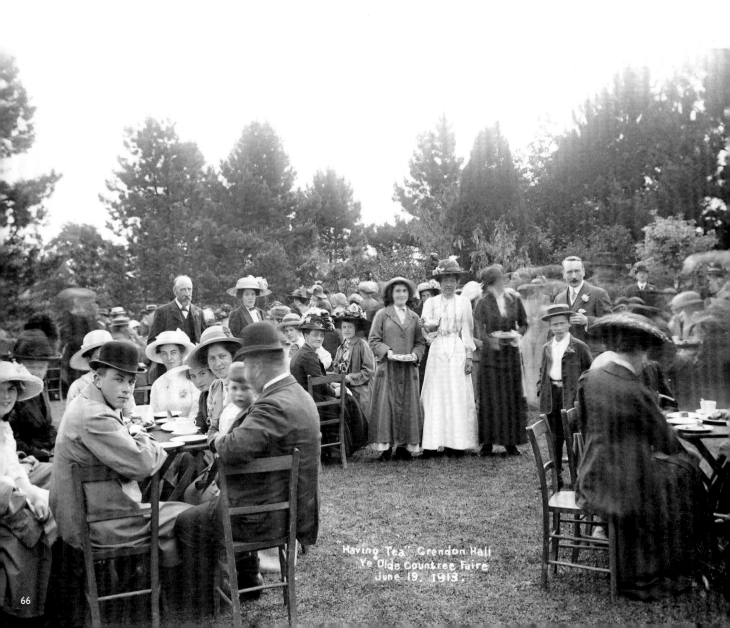

"Having Tea" Grendon Hall
Ye Olde Countree Faire
June 19. 1913.

Female wrestlers at St Giles' Fair,
Oxford, Oxfordshire.
Henry Taunt
1909

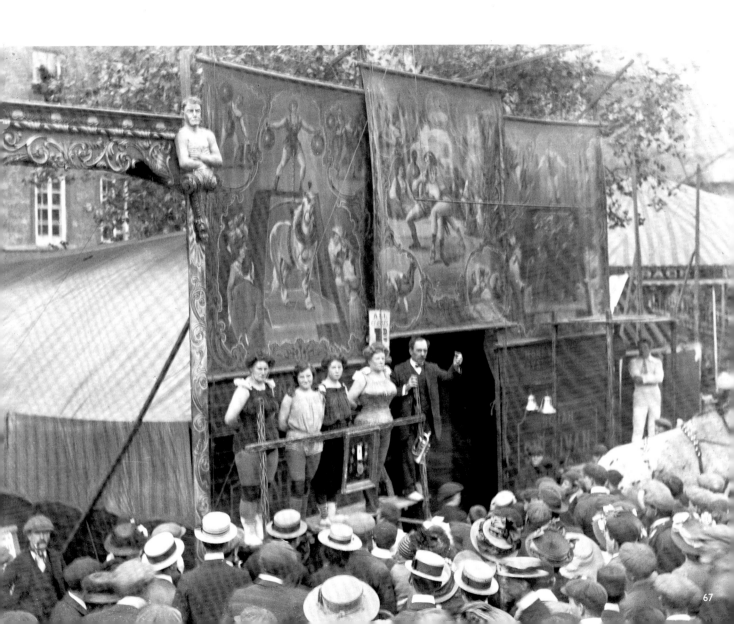

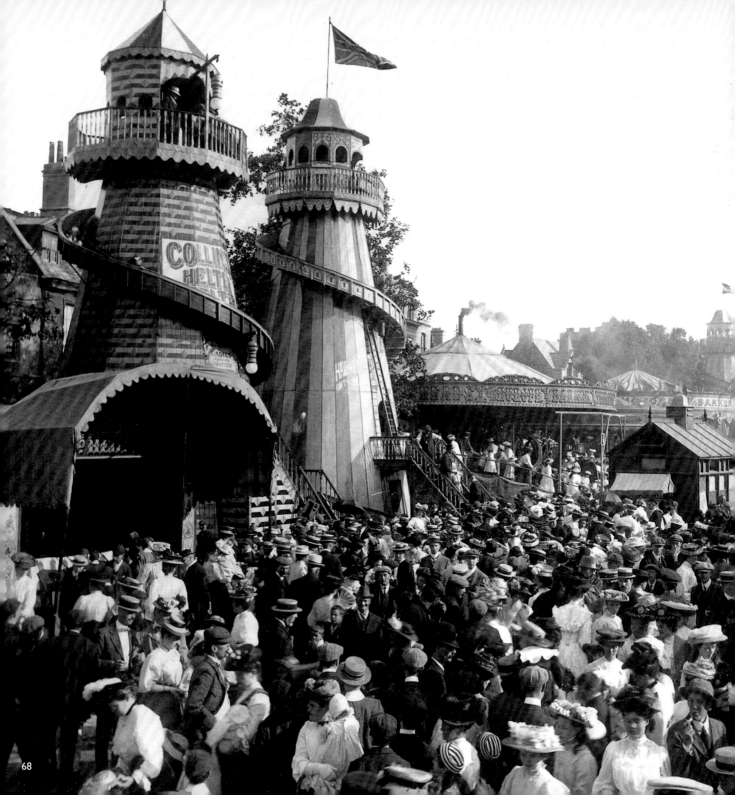

Helter skelters at St Giles'
Fair, Oxford, Oxfordshire.
Henry Taunt
1907

Country dancing at a fair
at Upper Boddington,
Northamptonshire.
Alfred Newton and Son
1896-1920

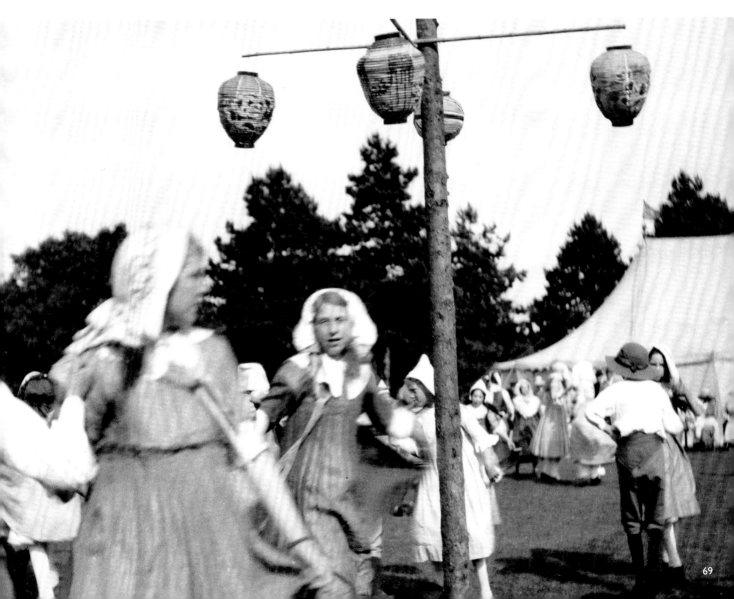

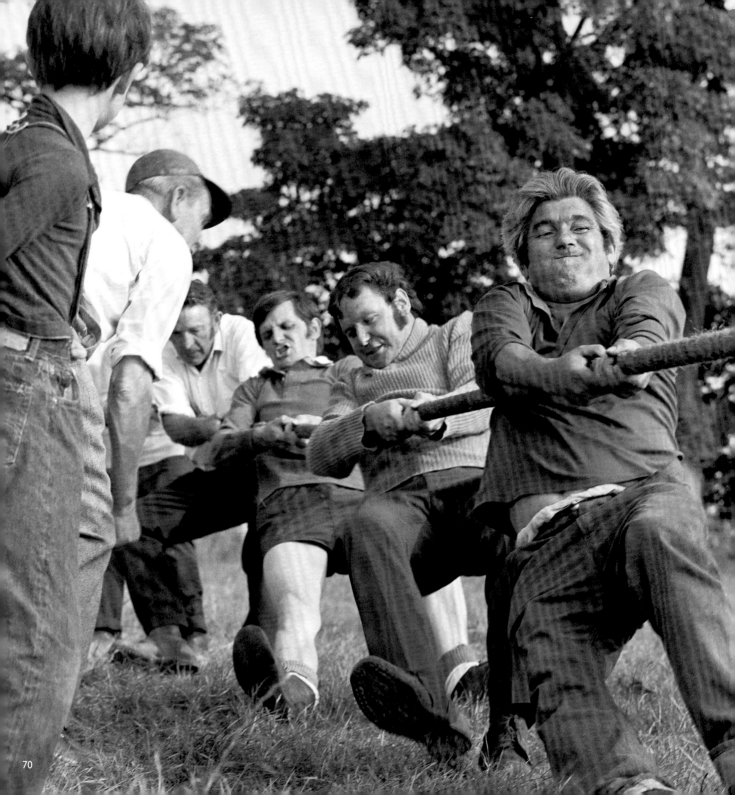

Tug of War competition at
Ashendon, Buckinghamshire.
John Gay
1971

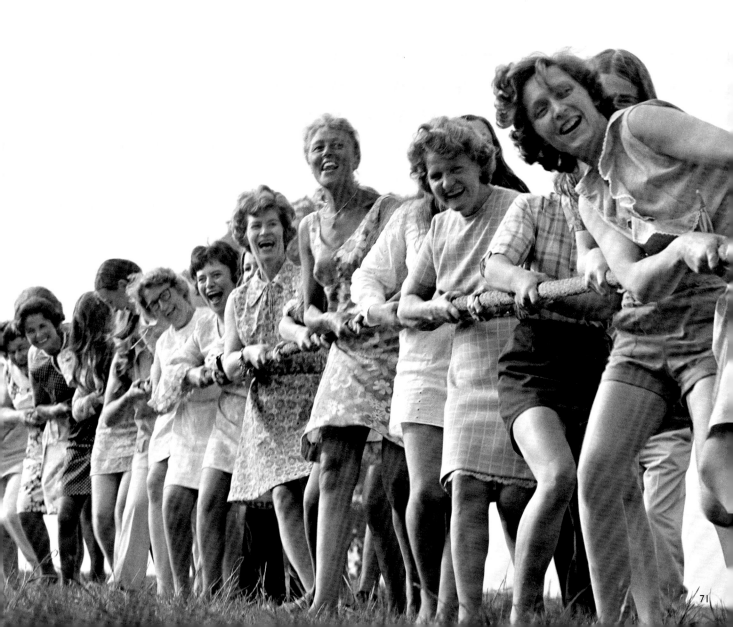

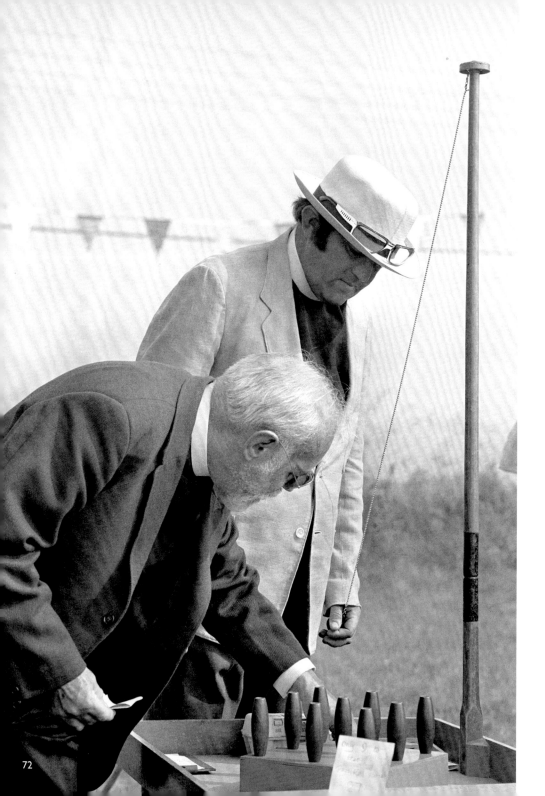

Clergymen playing
table skittles, Ashendon,
Buckinghamshire.
John Gay
1971

Swingboats at a fair
on Hampstead Heath,
London.
John Gay

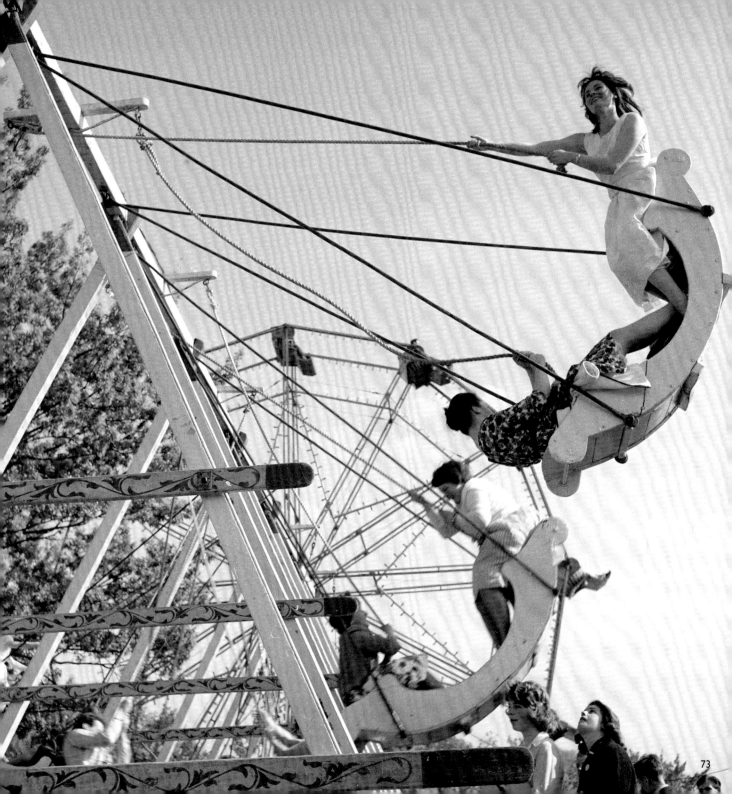

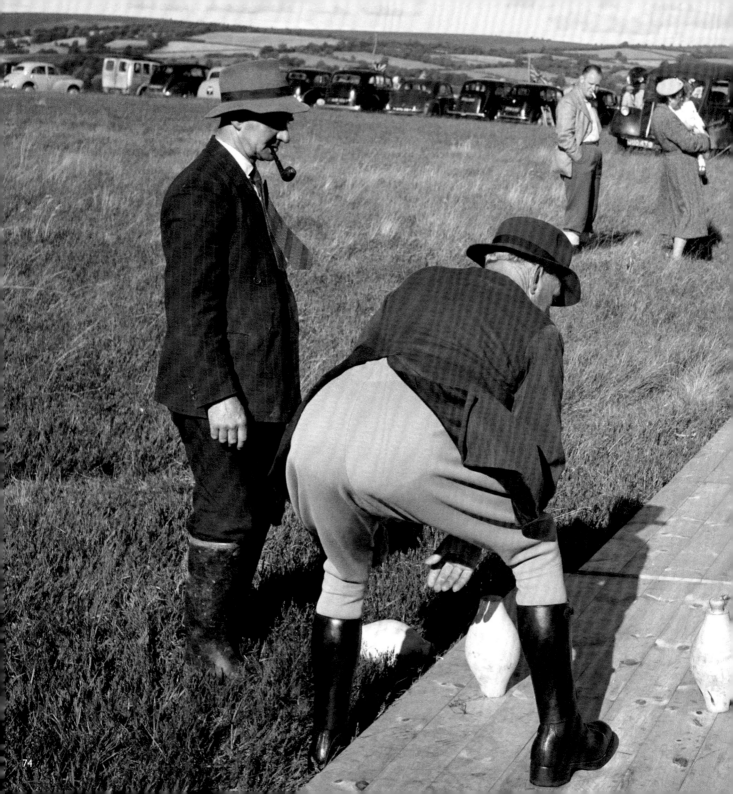

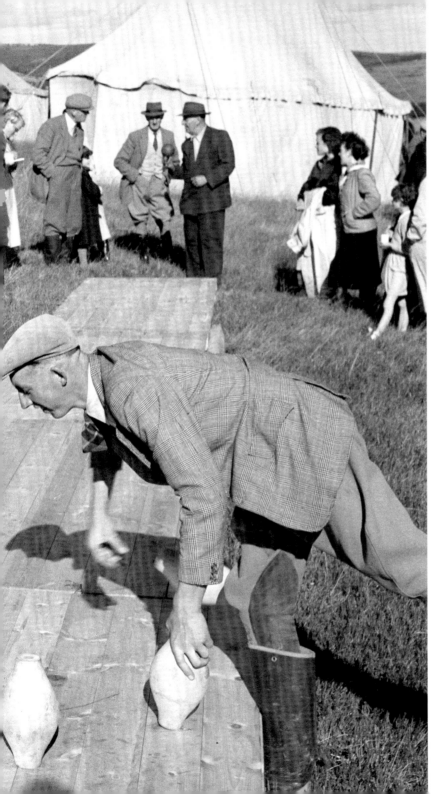

Skittles at Hawkesridge,
Somerset.
John Gay

HOBBIES &
PASTIMES

"My father was one of a team of six bellringers practising in the church when the vicar came in. He watched for a while, then said he could do that easily. He got hold of the rope, wound it round his wrist and pulled. Next minute he shot into the air. His head hit the roof and they had to carry him out."

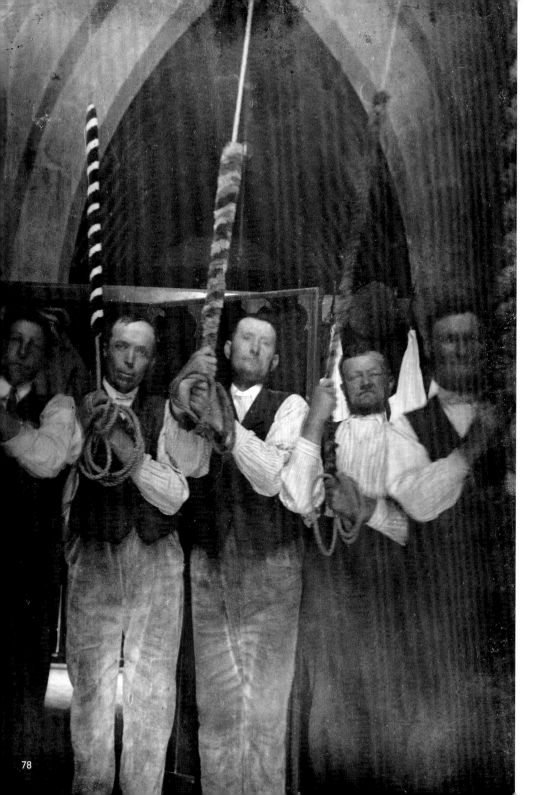

Bellringers,
Gloucestershire.
Alfred Newton and Son
1908

Fishing on the
River Thames near
Abingdon Bridge,
Oxfordshire.
Eric de Maré
1949

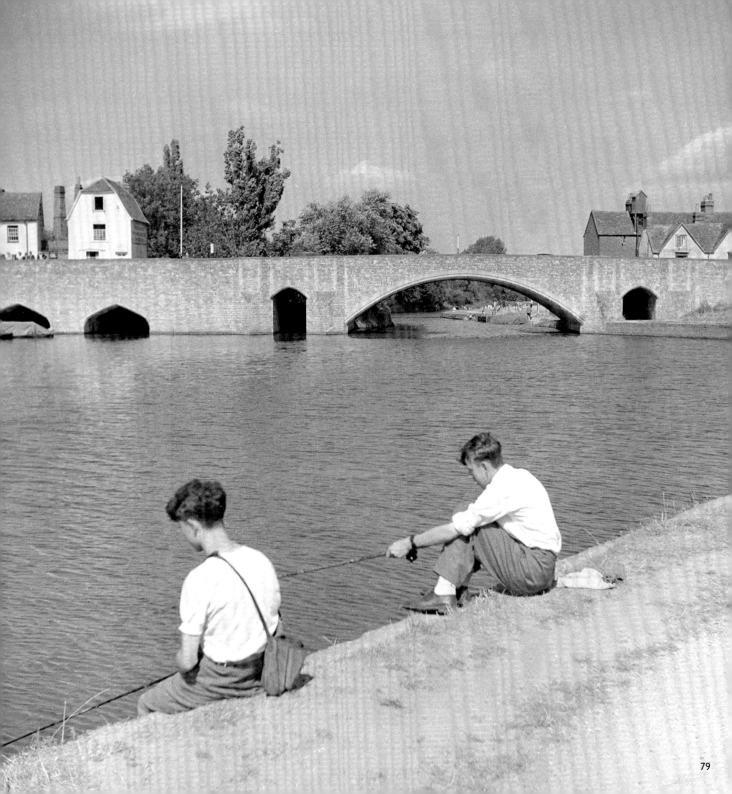

The Misses Bromley with
their bicycles at Byfield,
Northamptonshire.
Alfred Newton and Son
1904

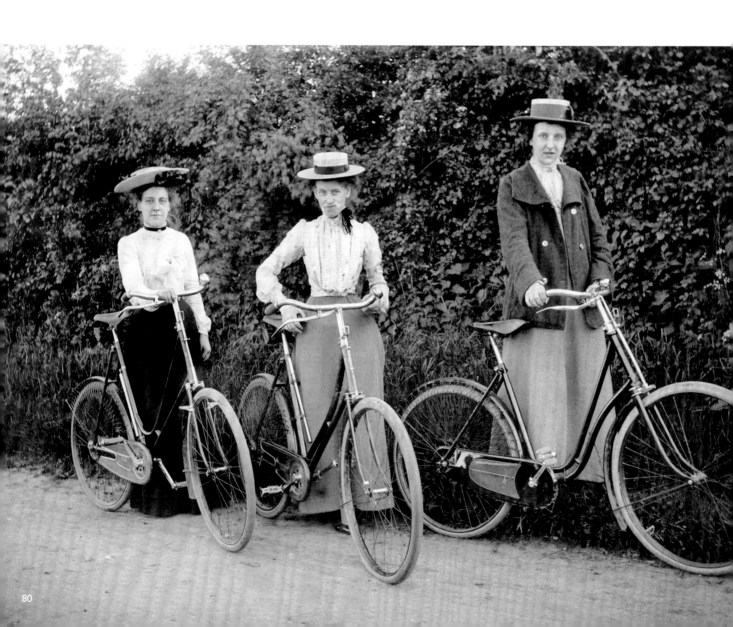

Cyclists in Hyde Park, London.
York and Son
1870-1900

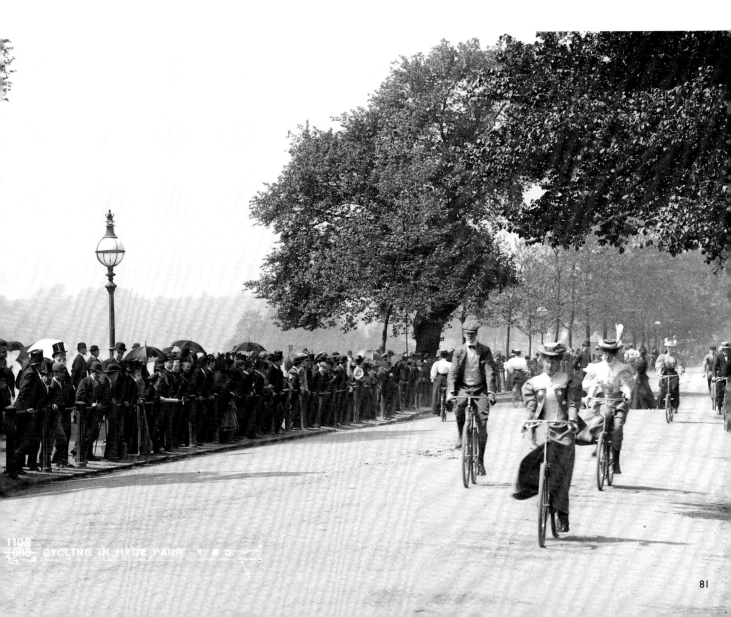

Skating near Abingdon, Oxfordshire.
Henry Taunt
1895

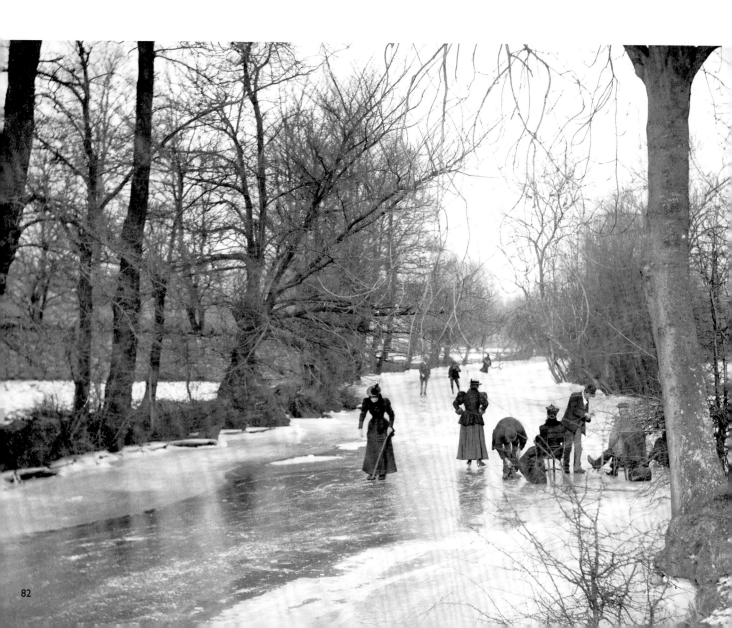

Fishing over a weir on the
River Medway, Tonbridge, Kent.
Alfred Newton and Son
1903

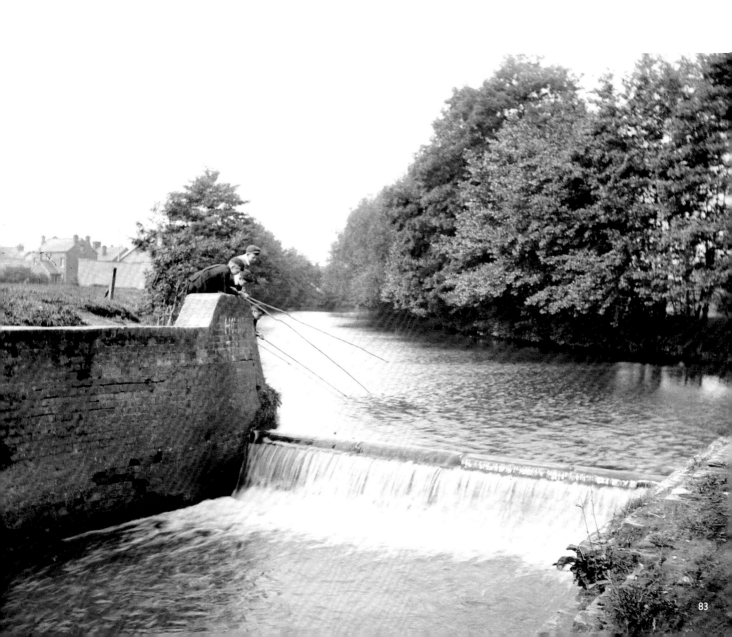

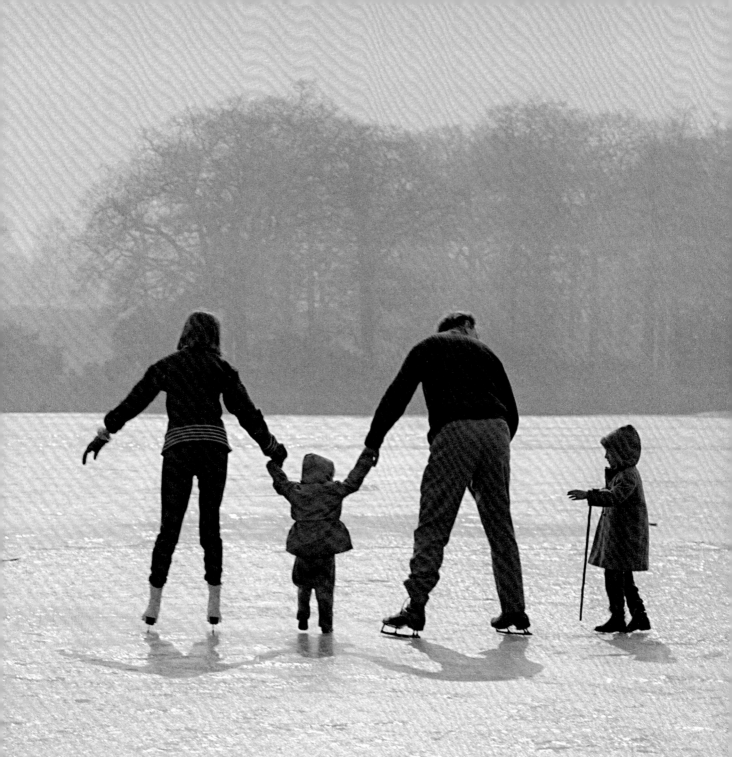

A family ice skating
in Richmond Park, London.
John Gay
1962-1964

Sewing and reading in the
gardens of Somerville College,
Oxford, Oxfordshire.
Henry Taunt
1895

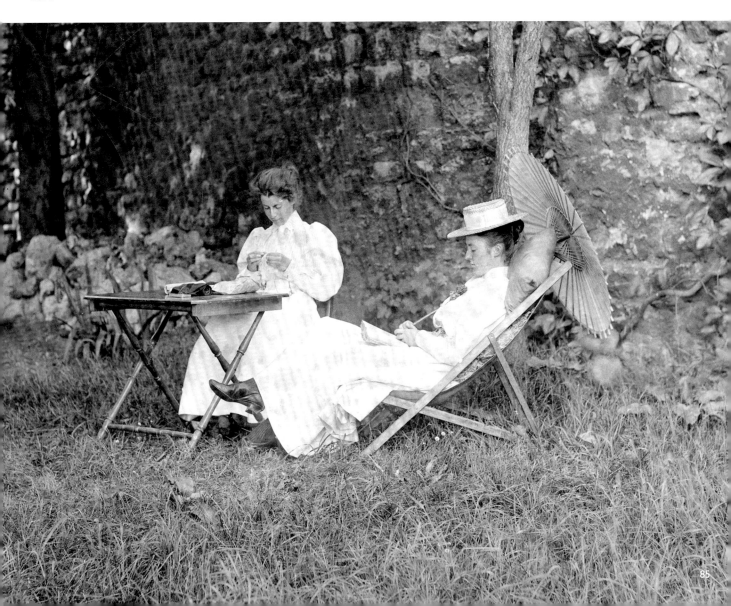

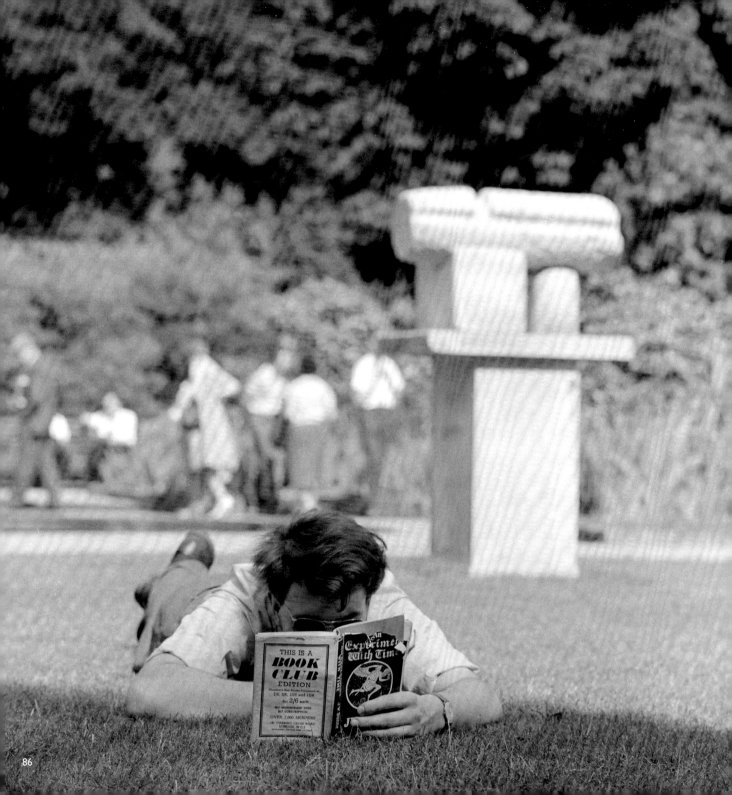

THIS IS A
**BOOK
CLUB**
EDITION
Members Net Books Published at
7/6, 8/6, 10/6 and 12/6
for 2/6 each
NO MEMBERSHIP FEES
NO SUBSCRIPTION
OVER 7,000 MEMBERS
181 CHARING CROSS ROAD
LONDON W.C.2

An Experiment With Time

Reading in a London park.
John Gay
1962-1964

Headington Quarry Morris Dancers
outside the Chequers public house,
Oxford, Oxfordshire.
Henry Taunt
1860-1922

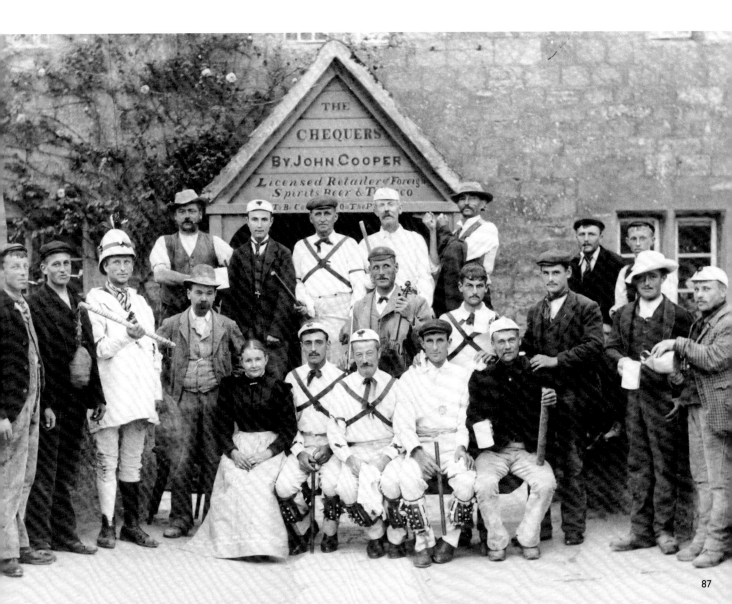

SPORT

"CRICKET was our favourite game. We played all day in a wood with two trees for wickets. We used to take it in turns to bat and bowl and the other trees were fieldsmen. We wore out two of my bats and many cork balls."

A cricket match at
Warkworth Castle,
Northumberland.
Hallam Ashley
1972

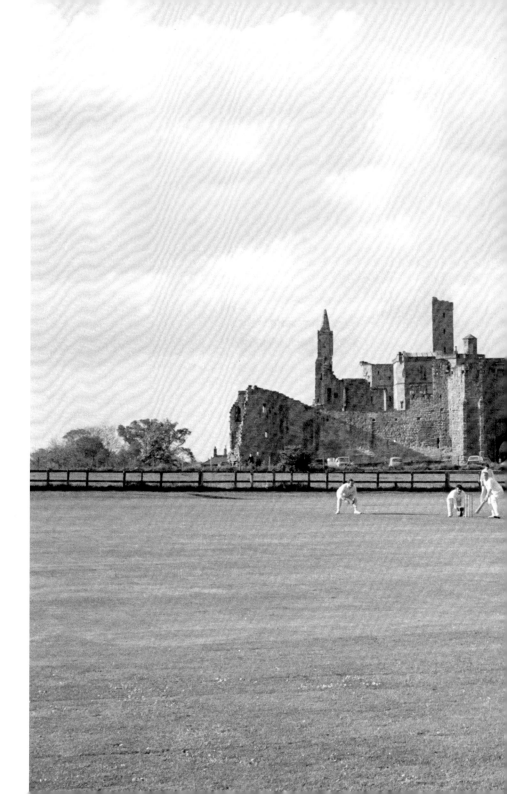

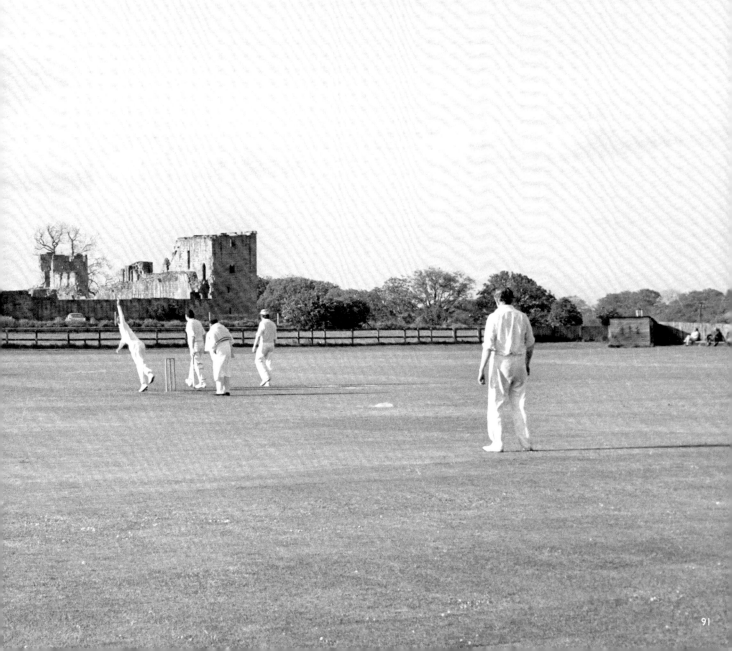

A fishing trip, Derwent Water,
Cumbria.
Alfred Newton and Son
1898

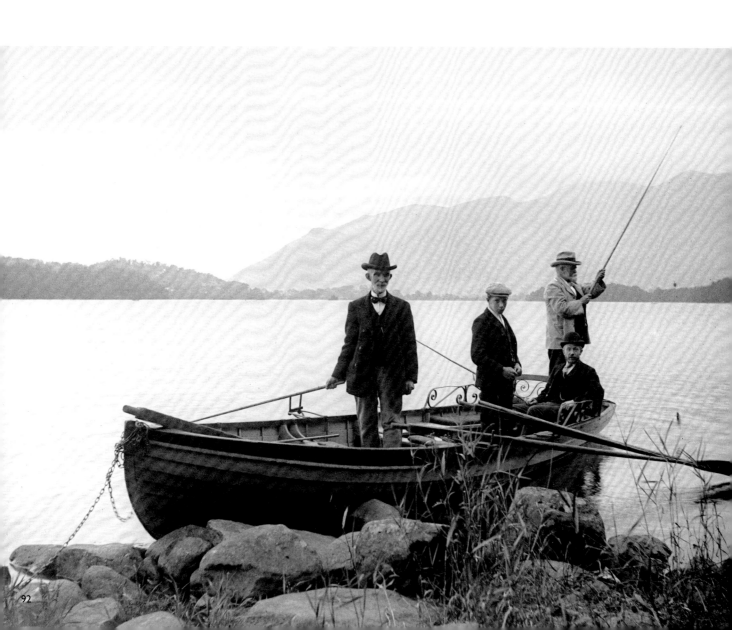

Flagg Moor Races, Derbyshire.
John Gay
1946-1955

Swimmers at Roehampton
swimming pool, Wandsworth,
London.
Herbert Felton
1934

The regatta at Beer, Devon.
Hallam Ashley
1950

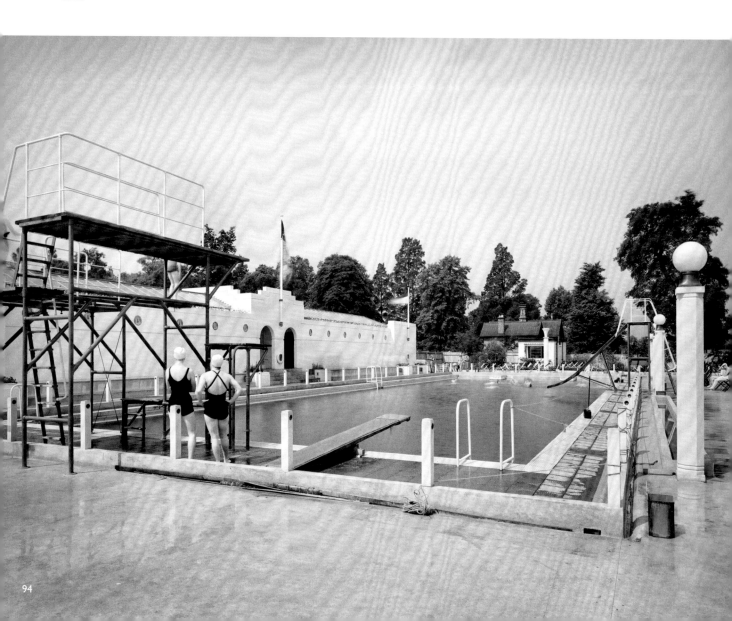

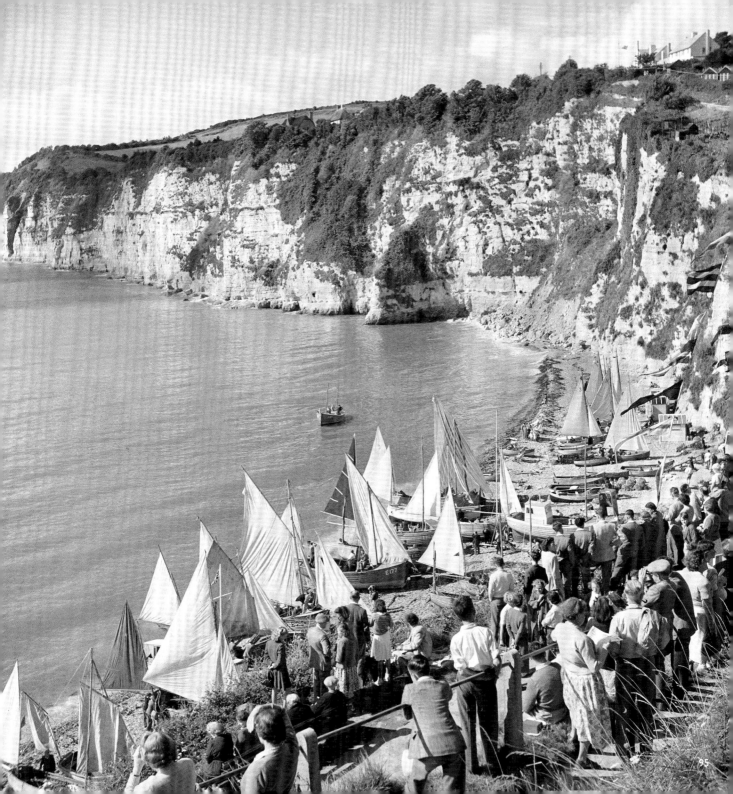

The bowling green at Port Sunlight,
Bebington, Merseyside.
Photographer unknown
1966

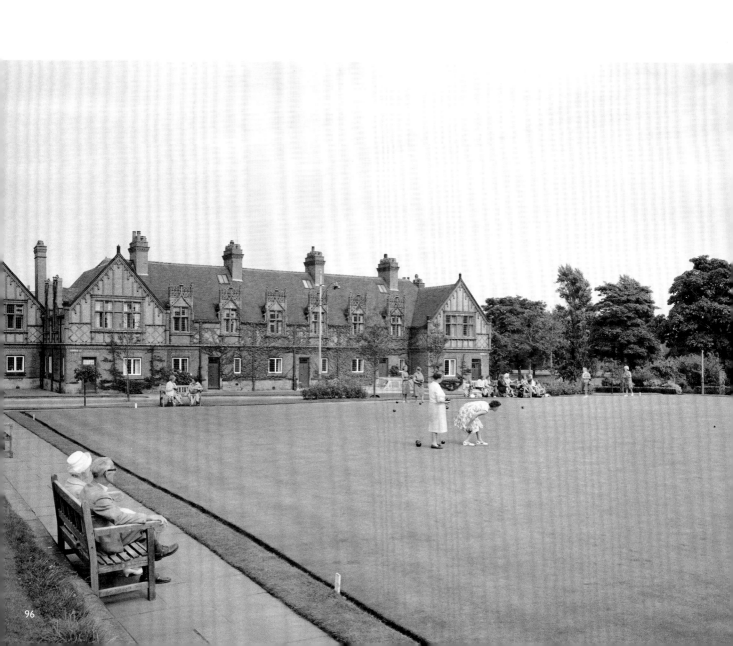

Cricket team posing outside
the Old Gaydon Inn, Warwickshire.
Alfred Newton and Son
1905

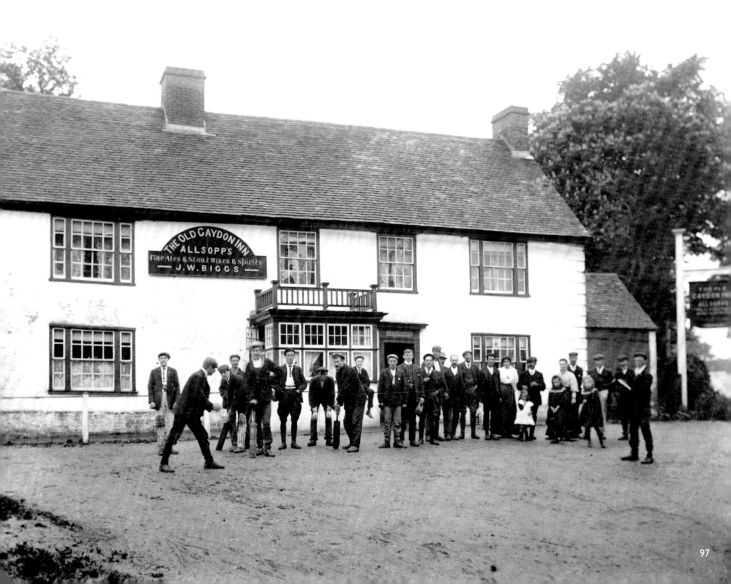

Spectators watching
football in Victoria Park,
London.
Laurence Goldman
1961

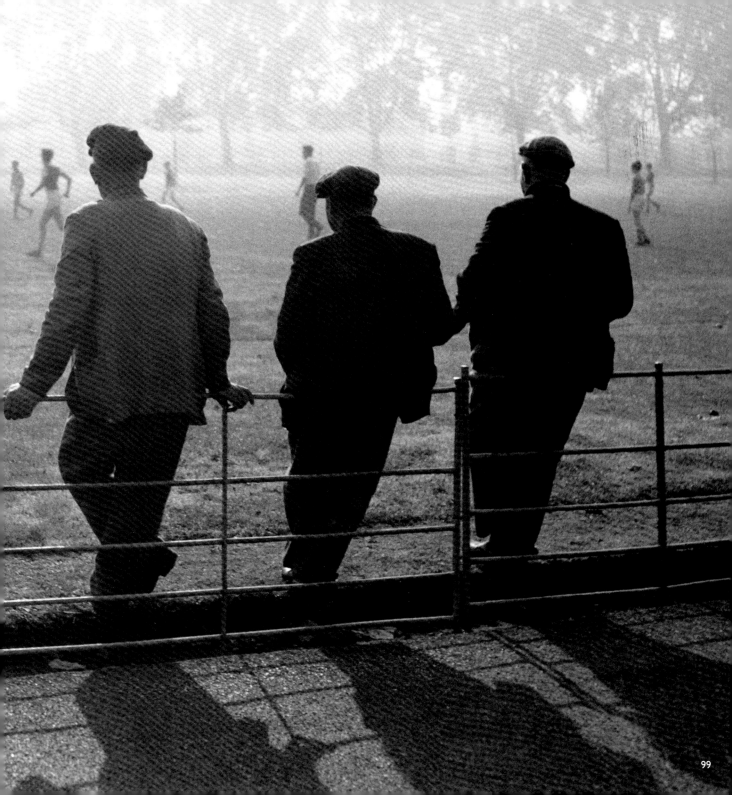

Posing in a tethered rowing boat,
Hellidon, Northamptonshire.
Alfred Newton and Son
1896-1920

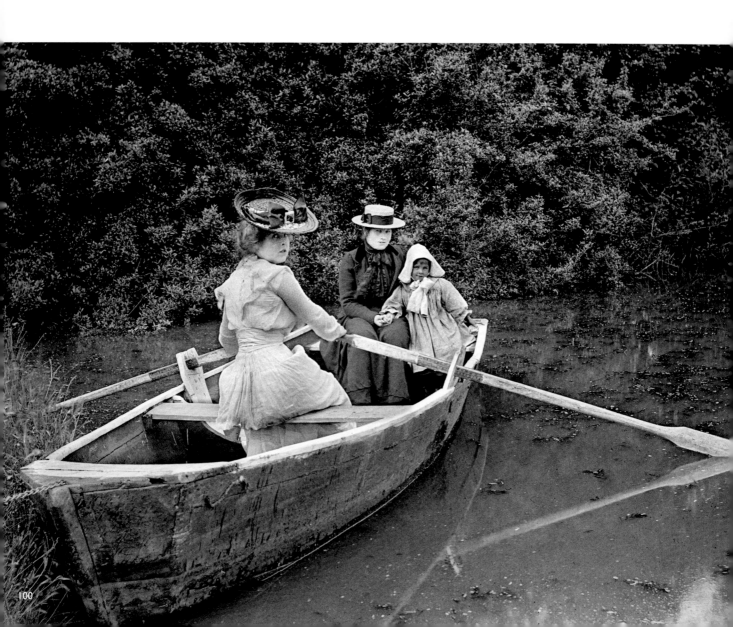

Rowing race on the River Thames,
Radley, Oxfordshire.
Henry Taunt
1860-1922

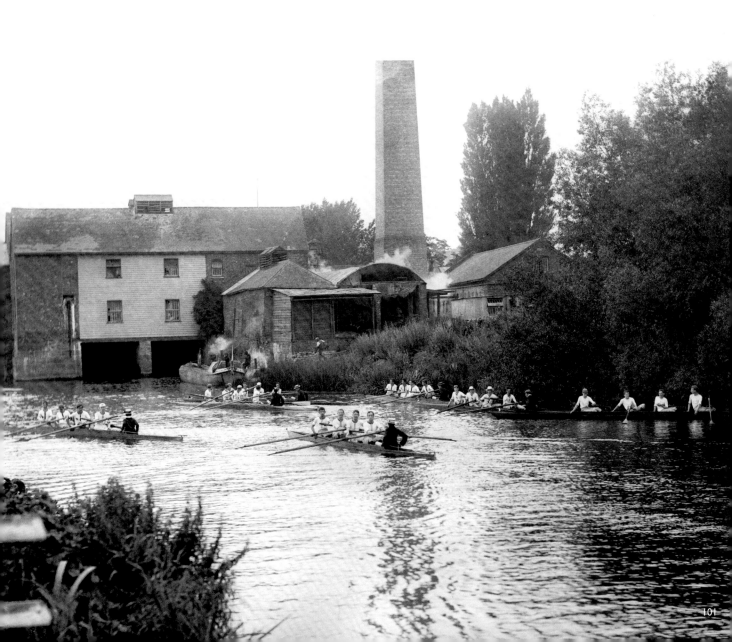

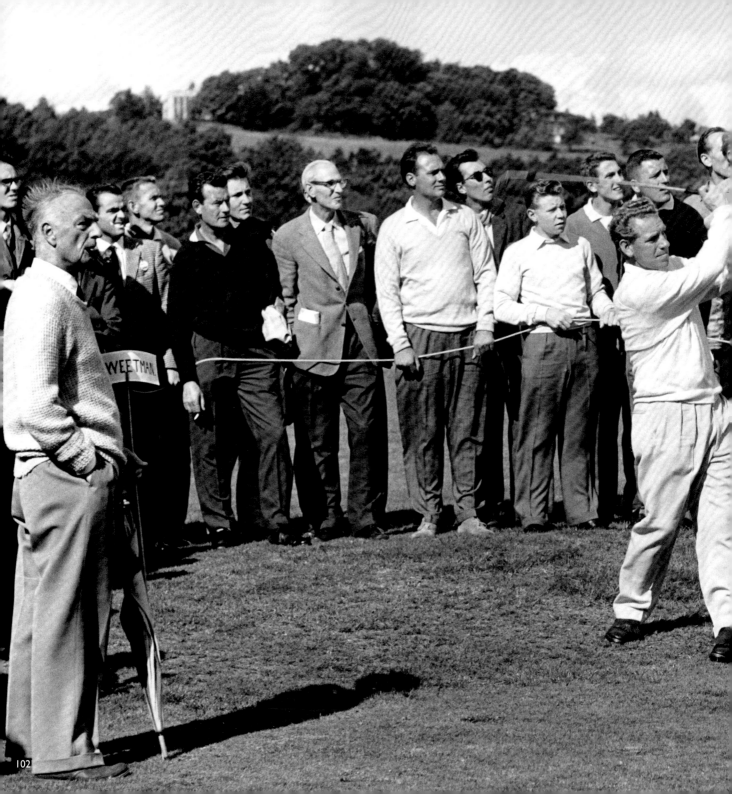

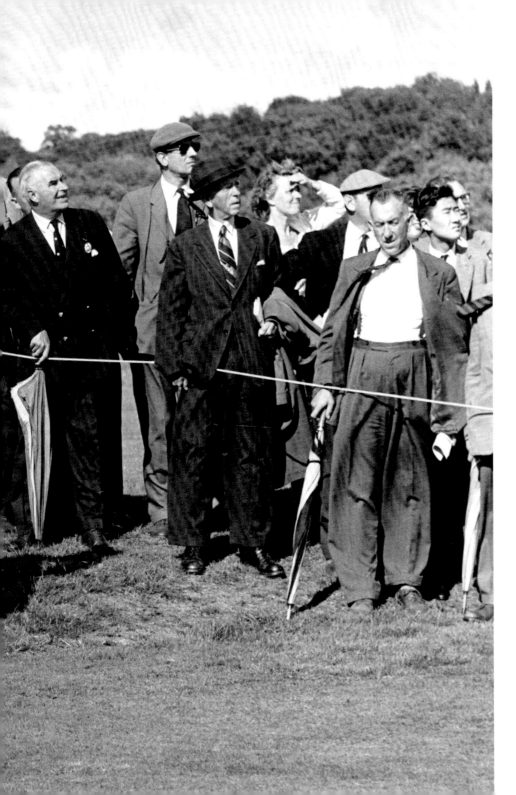

Harry Weetman
playing his second
shot at an exhibition
match, Mill Hill,
London.
Laurence Goldman
1960

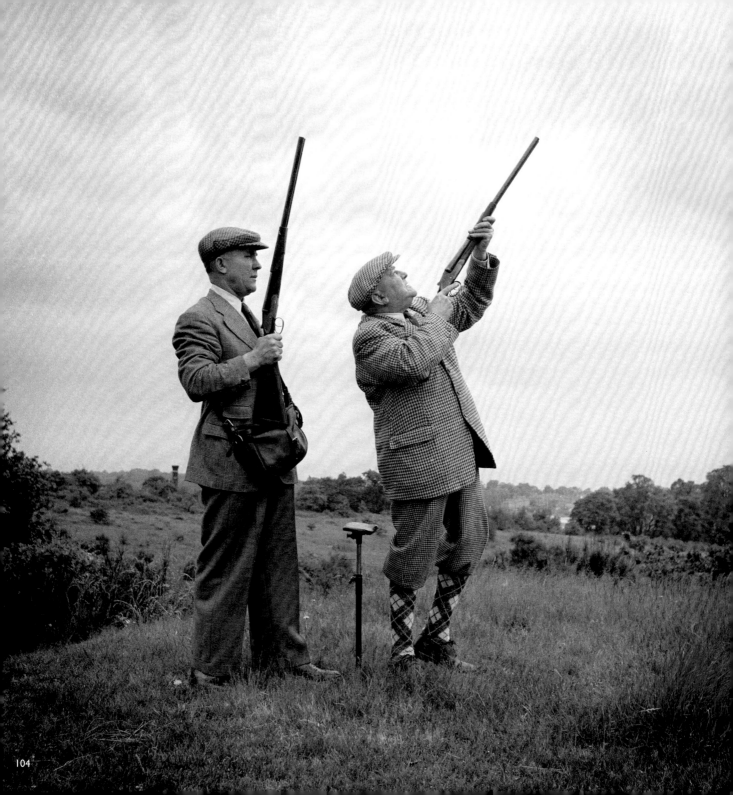

Shooting on the Holkham Hall
estate, Norfolk.
John Gay

Athletics at Battersea Park,
London.
John Gay
1973

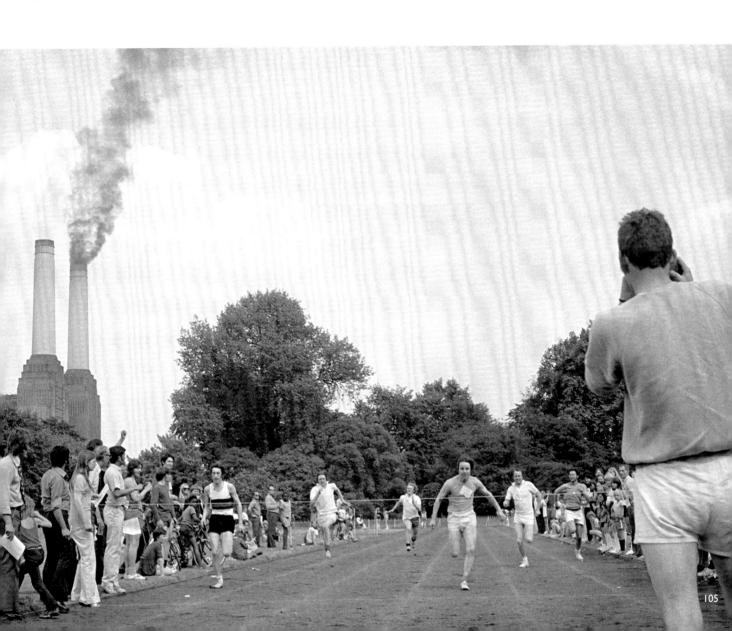

A tennis match in Princes
Risborough, Buckinghamshire.
Alfred Newton and Son
1986-1920

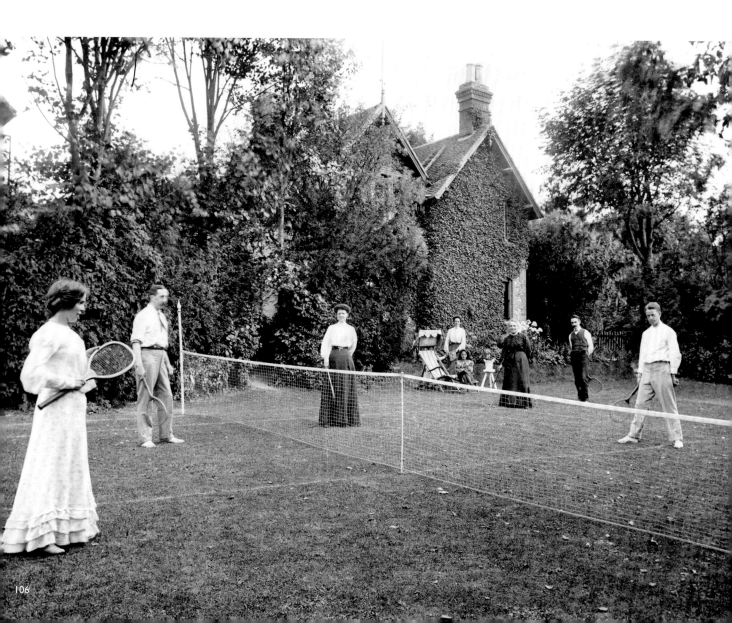

Hockey practice at Somerville
College, Oxford, Oxfordshire.
Henry Taunt
1860-1922

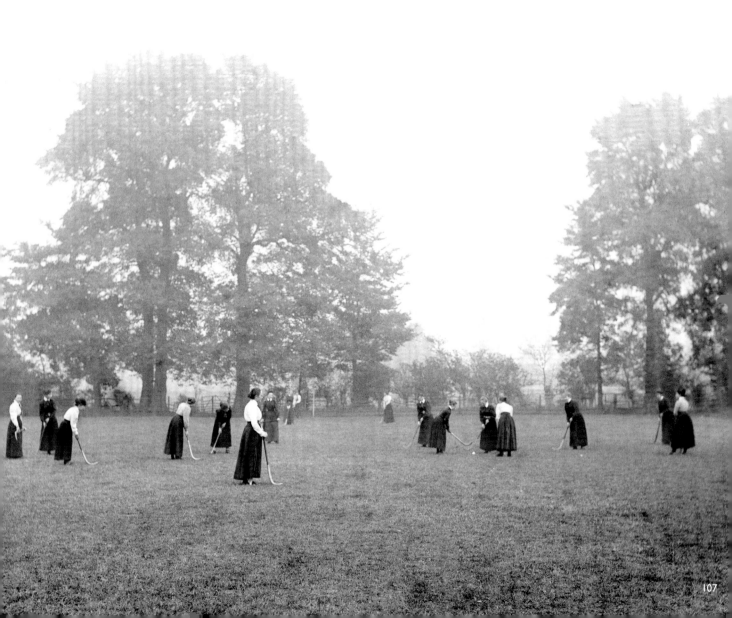

The cricket team of Hellidon
or Catesby, Northamptonshire,
posing for a team photograph.
Alfred Newton and Son
1896-1920

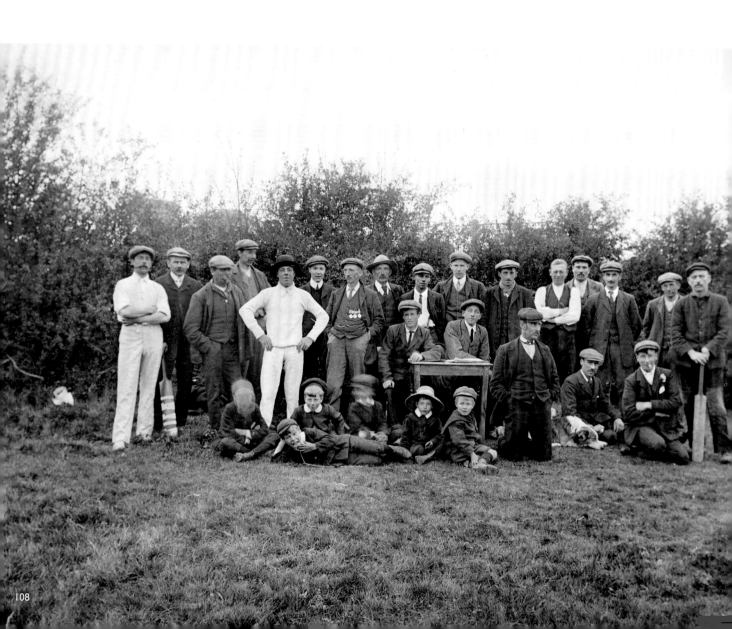

A crowd watch a golf match at
Chilswell Golf Links, Cumnor,
Oxfordshire.
Henry Taunt
1860-1922

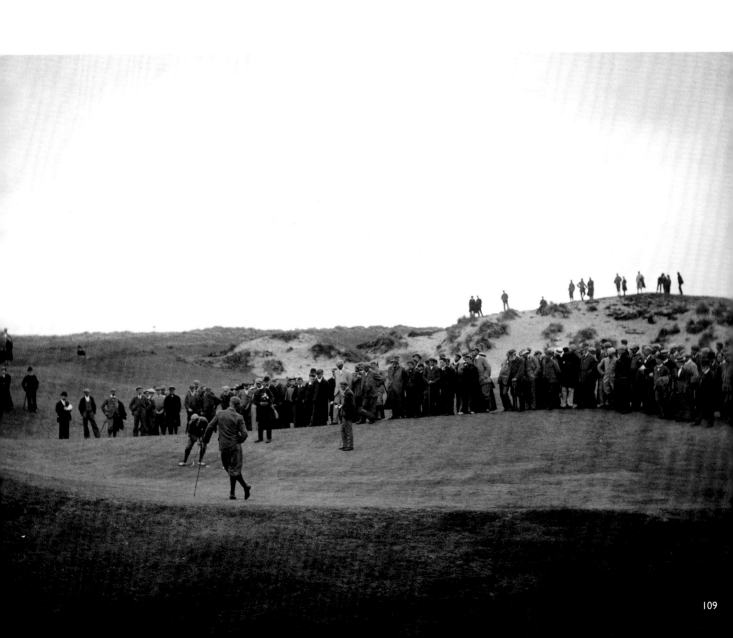

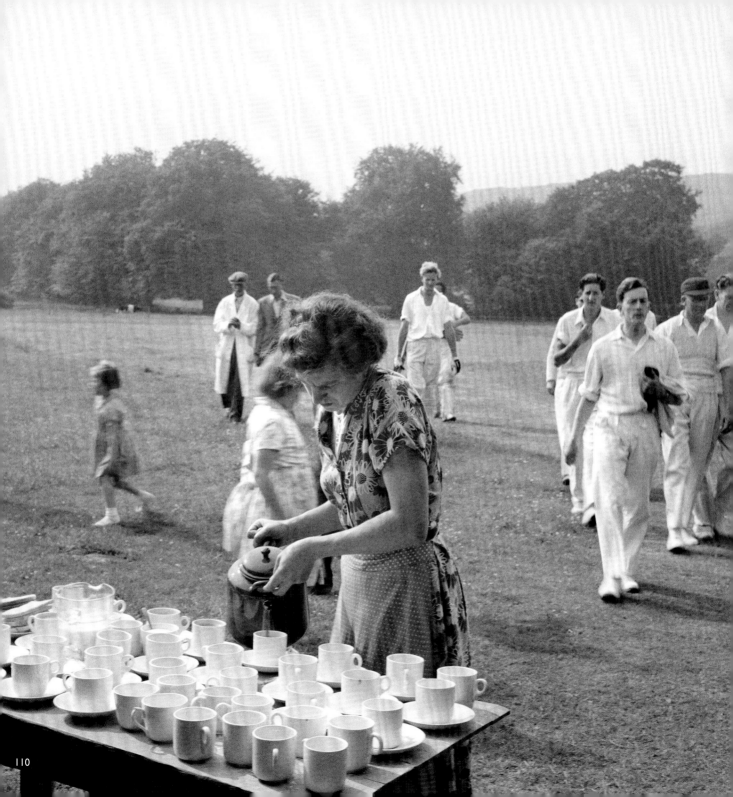

Tea interval at
a cricket match,
East Dean, Sussex.
John Gay
1946-1955

Lord's during the
Middlesex versus
Surrey cricket
match, London.
Laurence Goldman
1960

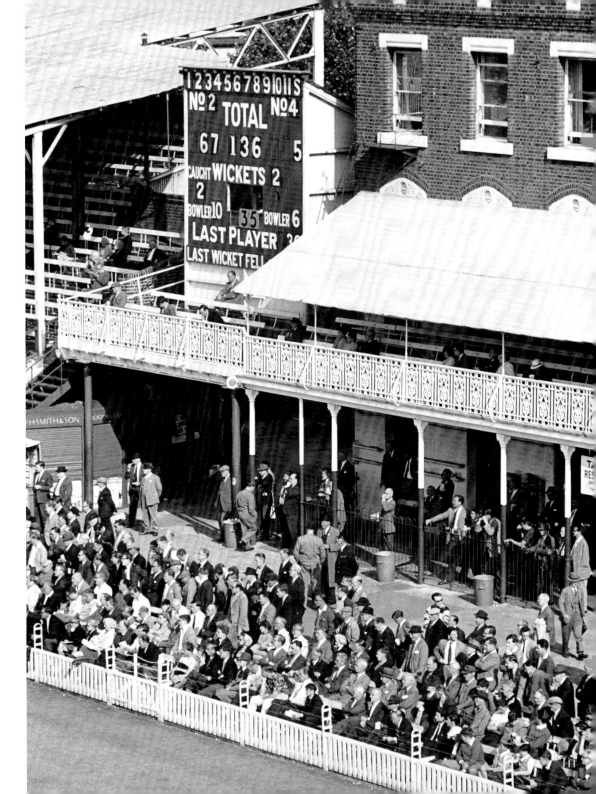

111

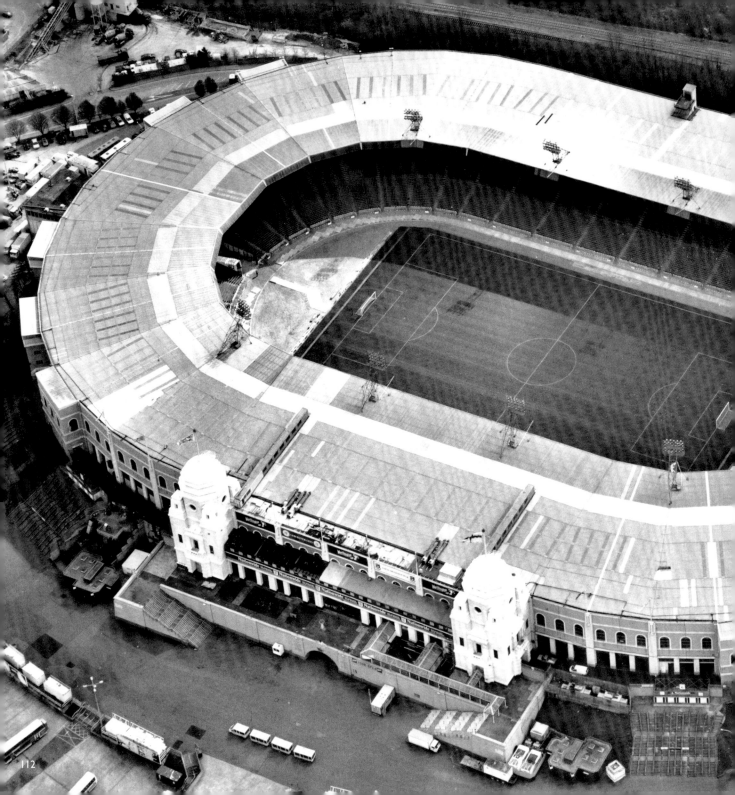

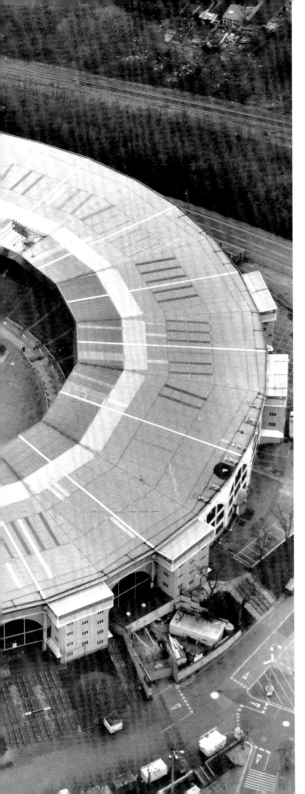

An aerial view of Wembley Stadium,
London.
NMR
1999

FANCY DRESS

"WE used to go mumming. We would dress up in old hats and black our faces. You were supposed to make yourself unrecognisable and people had to guess who you were."

A fancy dress party at Hellidon,
Northamptonshire.
Alfred Newton and Son
1907-1920

A dress rehearsal at Maddermarket
Theatre, Norwich, Norfolk.
Hallam Ashley
1950

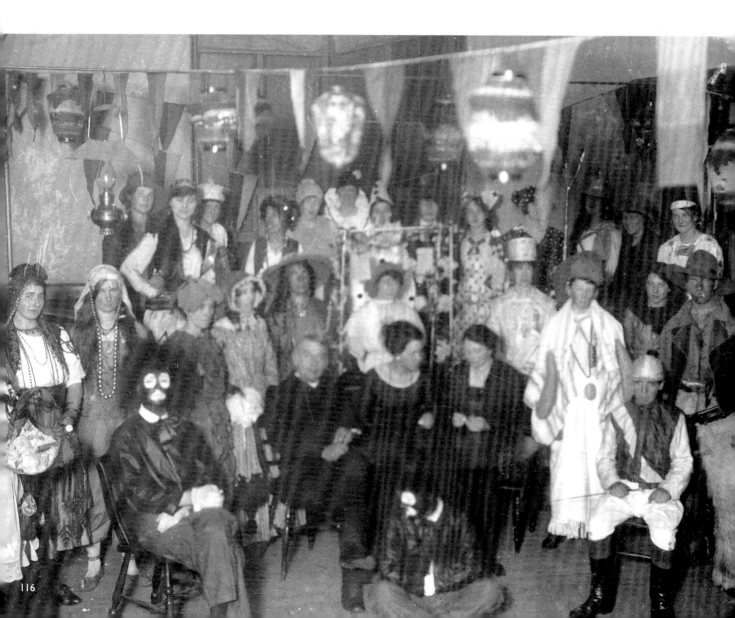

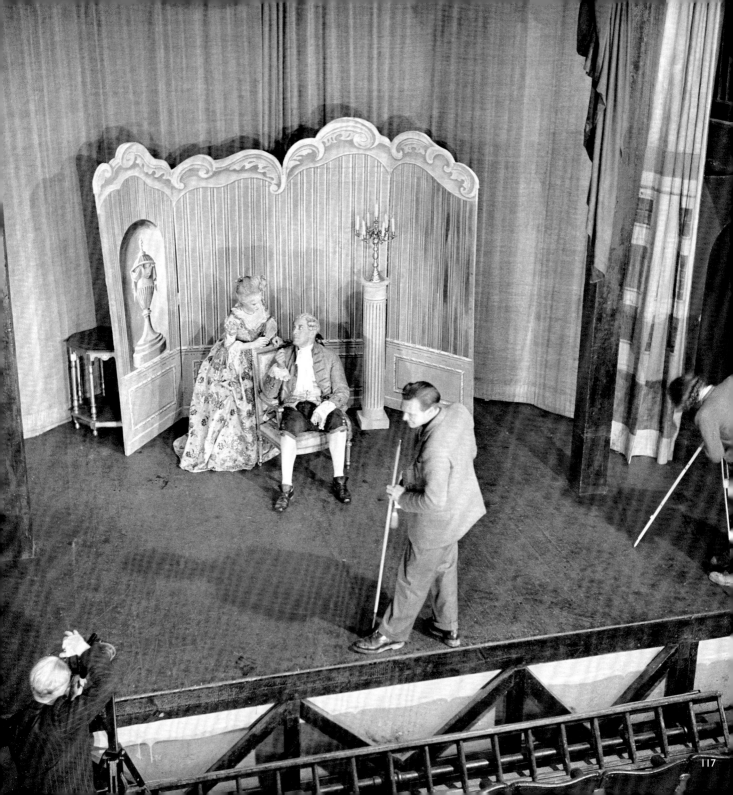

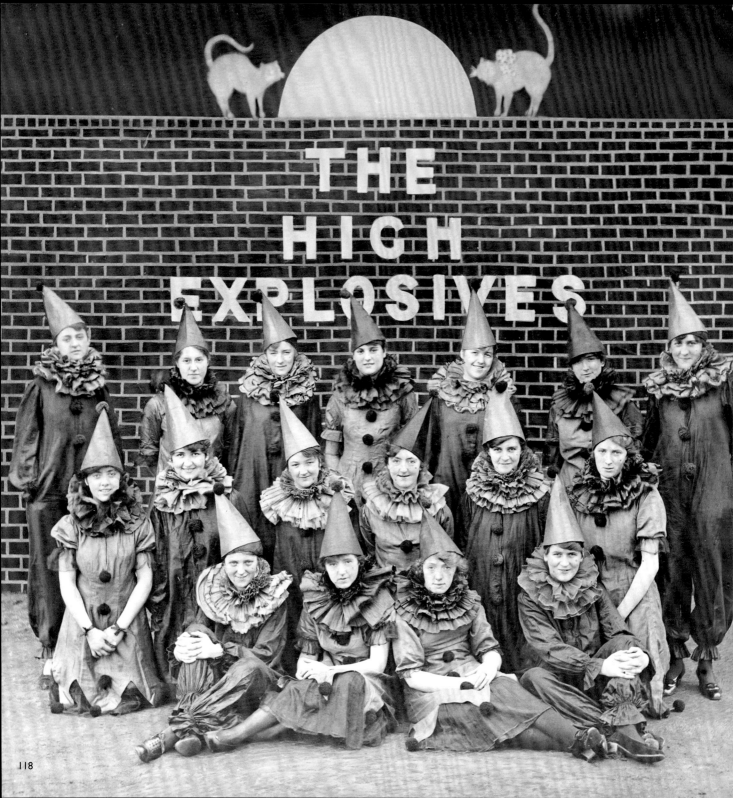

The High Explosives,
the Cunard Shell
Works concert party,
Birkenhead, Merseyside.
Bedford Lemere
1917

A man and woman
dressed as Darby and Joan.
Alfred Newton and Son
1907-1920

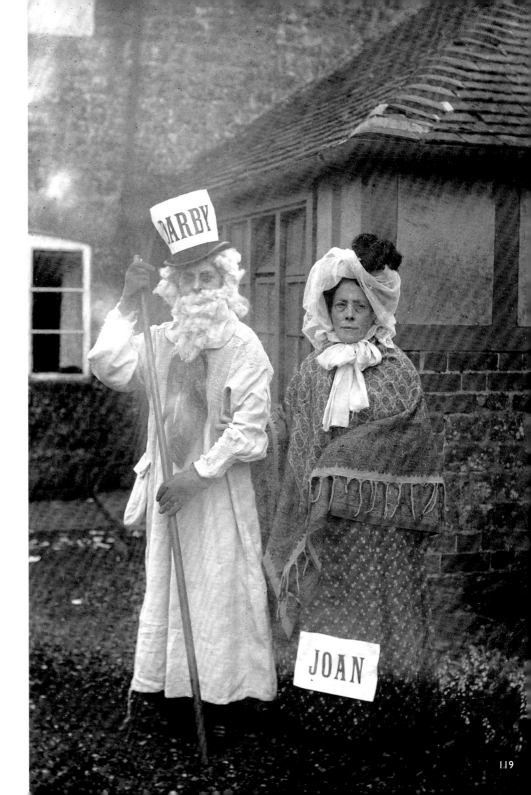

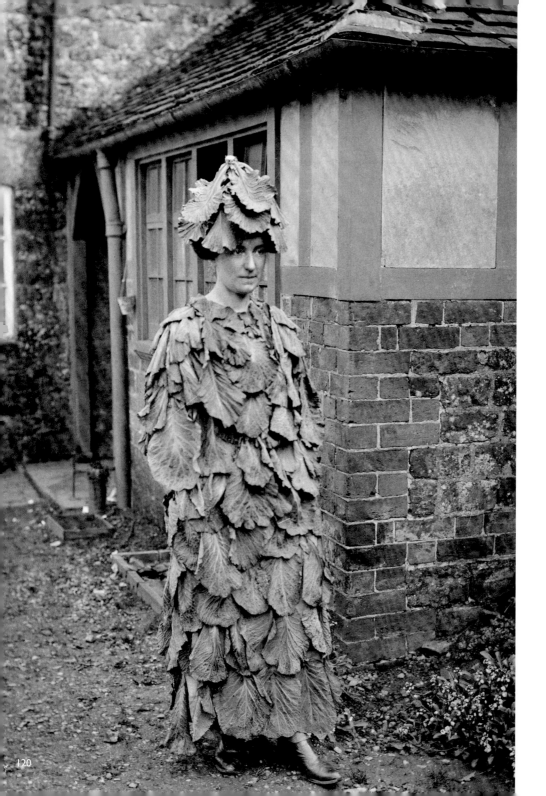

The 'Cabbage Lady',
Hellidon, Northamptonshire.
Alfred Newton and Son
1907-1920

A woman in an outfit made
of *Daily Express* newspapers.
Alfred Newton and Son
1907-1920

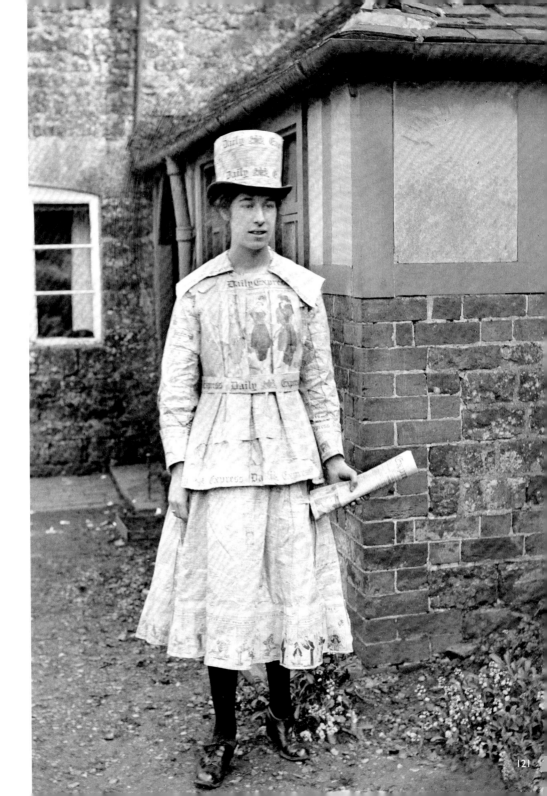

Ladies in fancy dress,
Hellidon, Northamptonshire.
Alfred Newton and Son
1907-1920

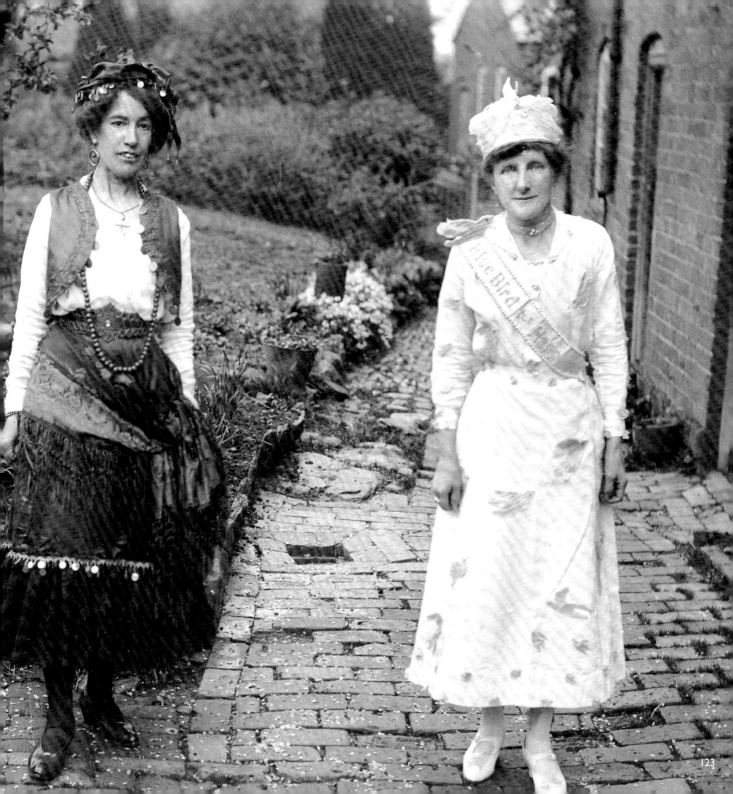

REFERENCE NUMBERS

National Monuments Record

The photographs in this book all come from the collections of the National Monuments Record (NMR).

The NMR is one of the largest publicly accessible archives in Britain and is the biggest dedicated to the historic environment. It is an unparalleled collection of images, old and new, which has been growing for over 60 years.

Set up as the National Buildings Record (NBR) in 1941 in response to the threat to historic buildings from aerial bombardment during World War II, it immediately began its own recording programme as well as collecting historic negatives and prints.

In 1963 it came under the auspices of the Royal Commission on the Historical Monuments of England and in 1999 was transferred to English Heritage. Today the collection comprises more than eight million photographs and other archive items relating to England's architecture and archaeology.

It continues to accept major collections of national importance and is a repository for material created by English Heritage's staff photographers. The collection may be consulted at the National Monuments Record office in Swindon.

Telephone 01793 414600 or email nmrinfo@english-heritage.org.uk for details.

If you would like enlargements of photographs in this book please call enquiries on 01793 414600 quoting the reference numbers on the right.